MAGICAL GARDEN

Adult Coloring book
Stress Relieving & Mindful Calm
Unique Creative Expiriance

Original Illustrations by Aemiliana Magnus
Copyrighted Material

Copyright © 2016 AEMILIANA MAGNUS
All rights reserved.

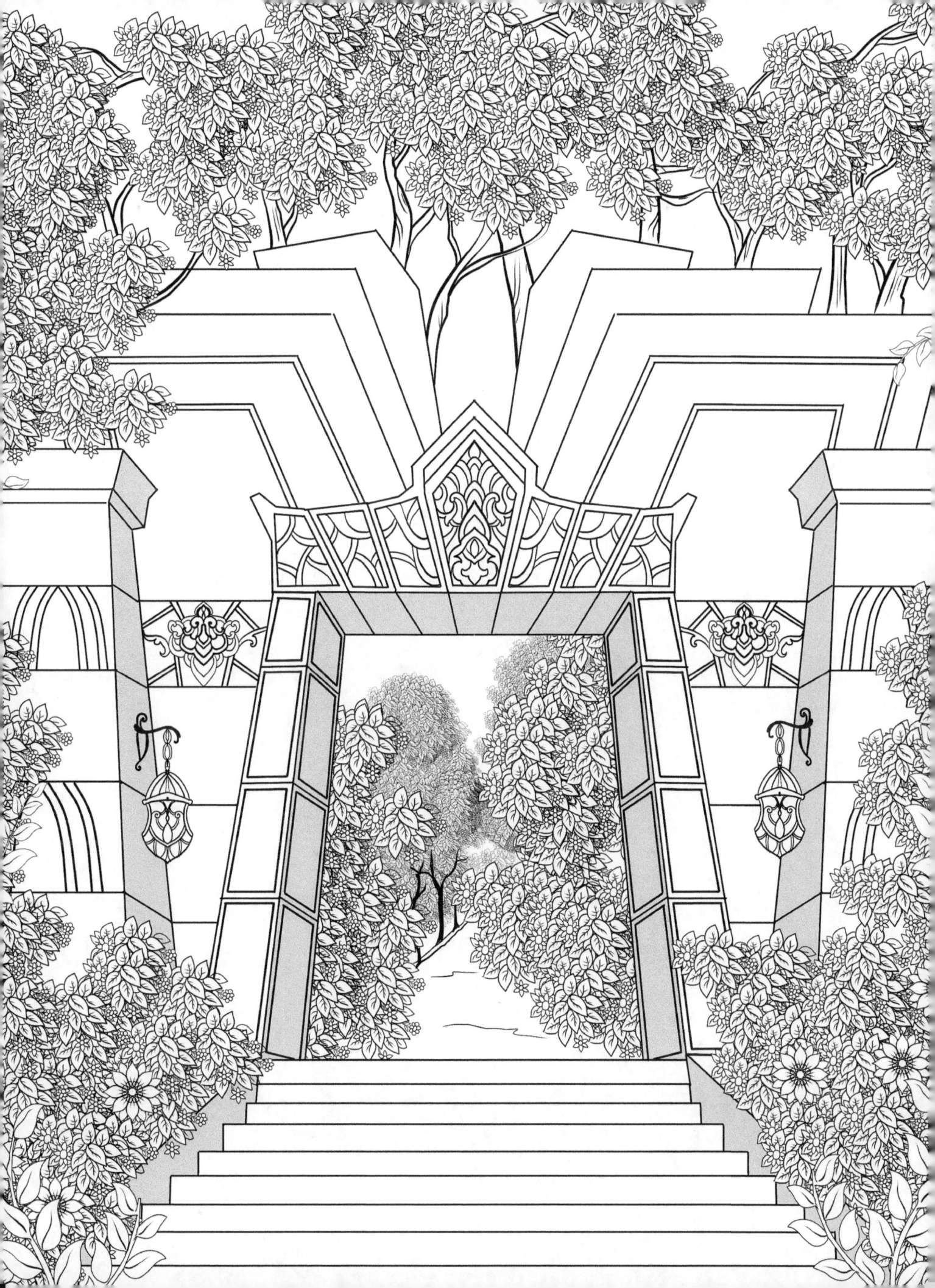

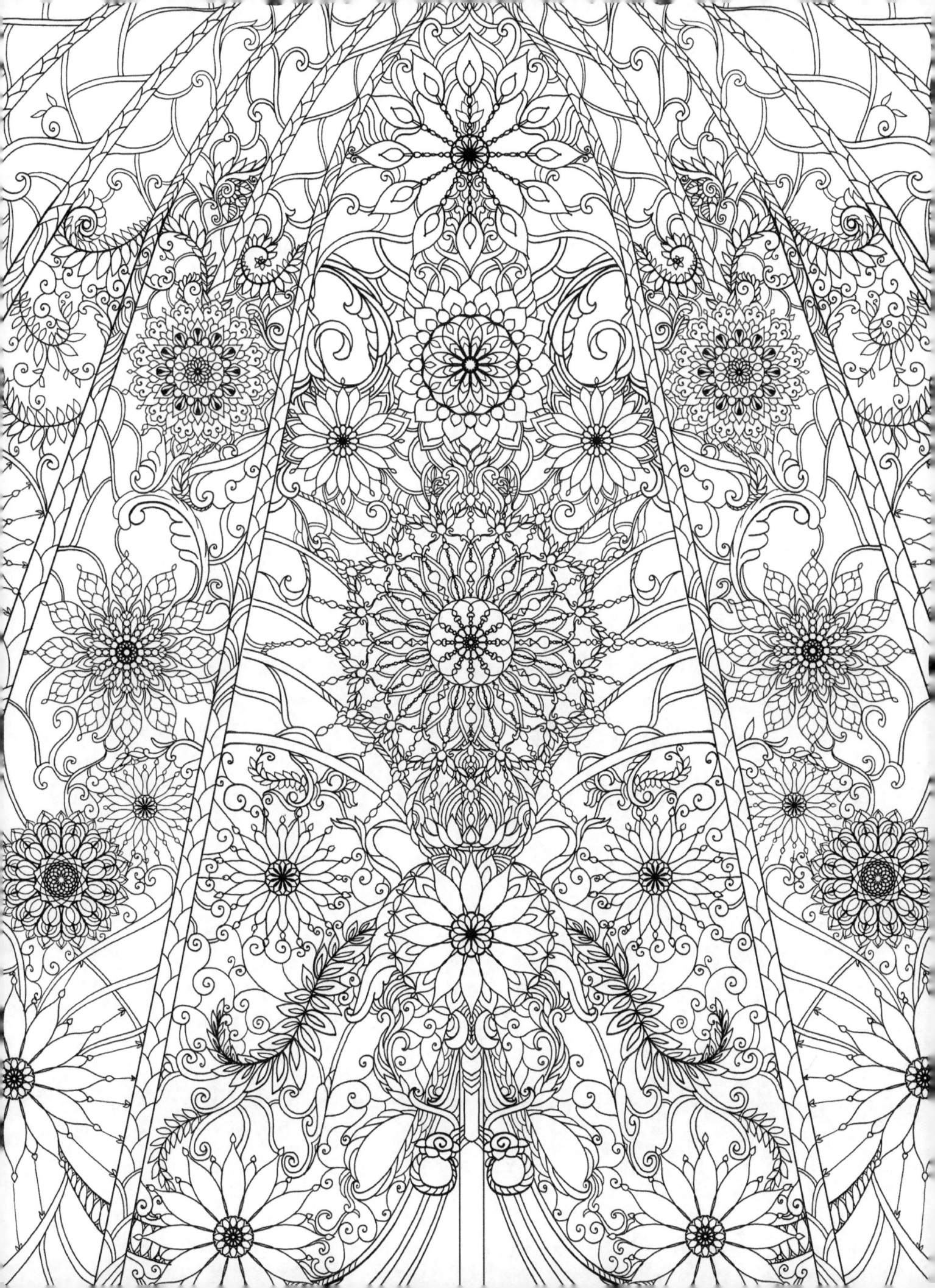

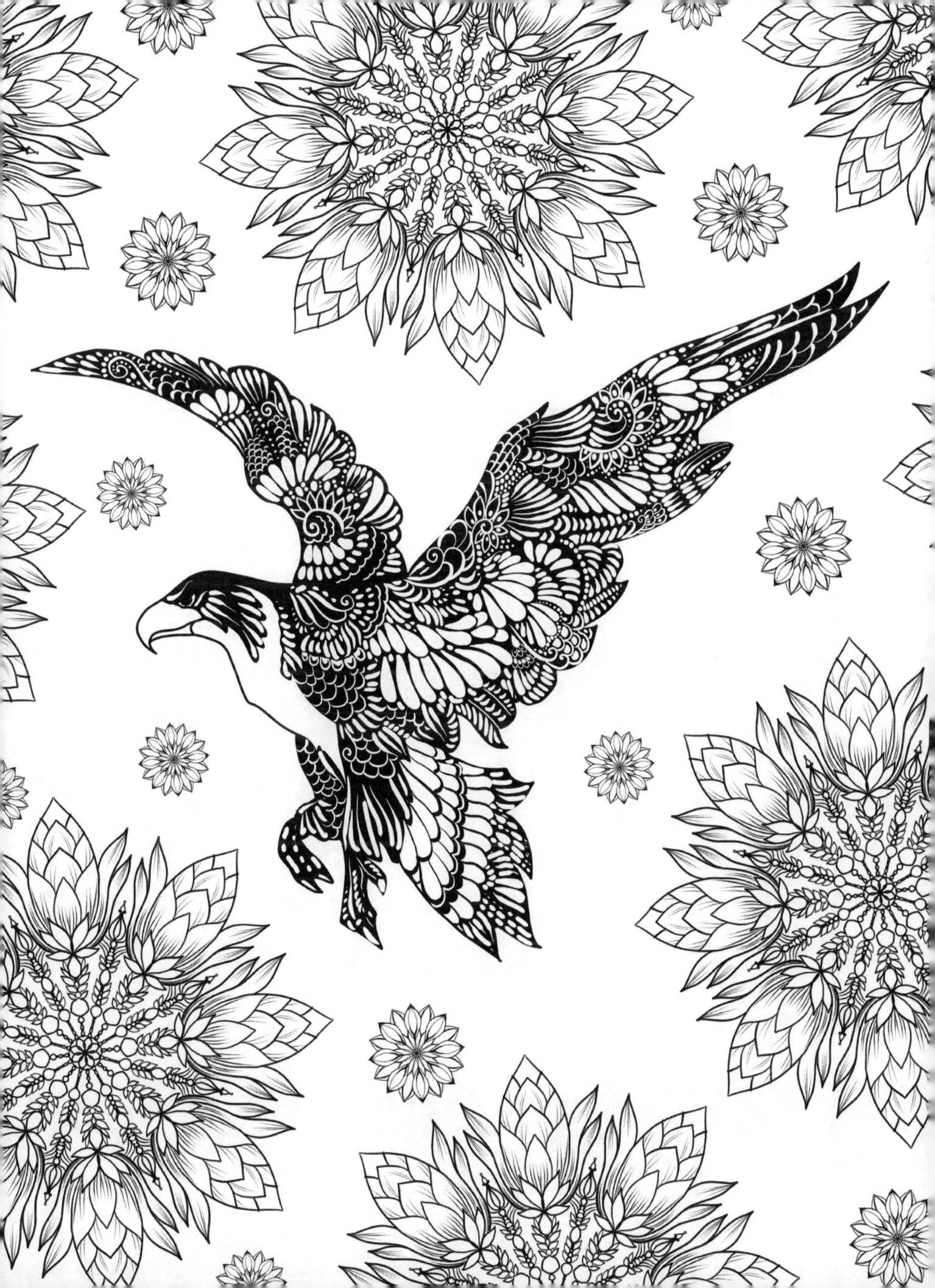

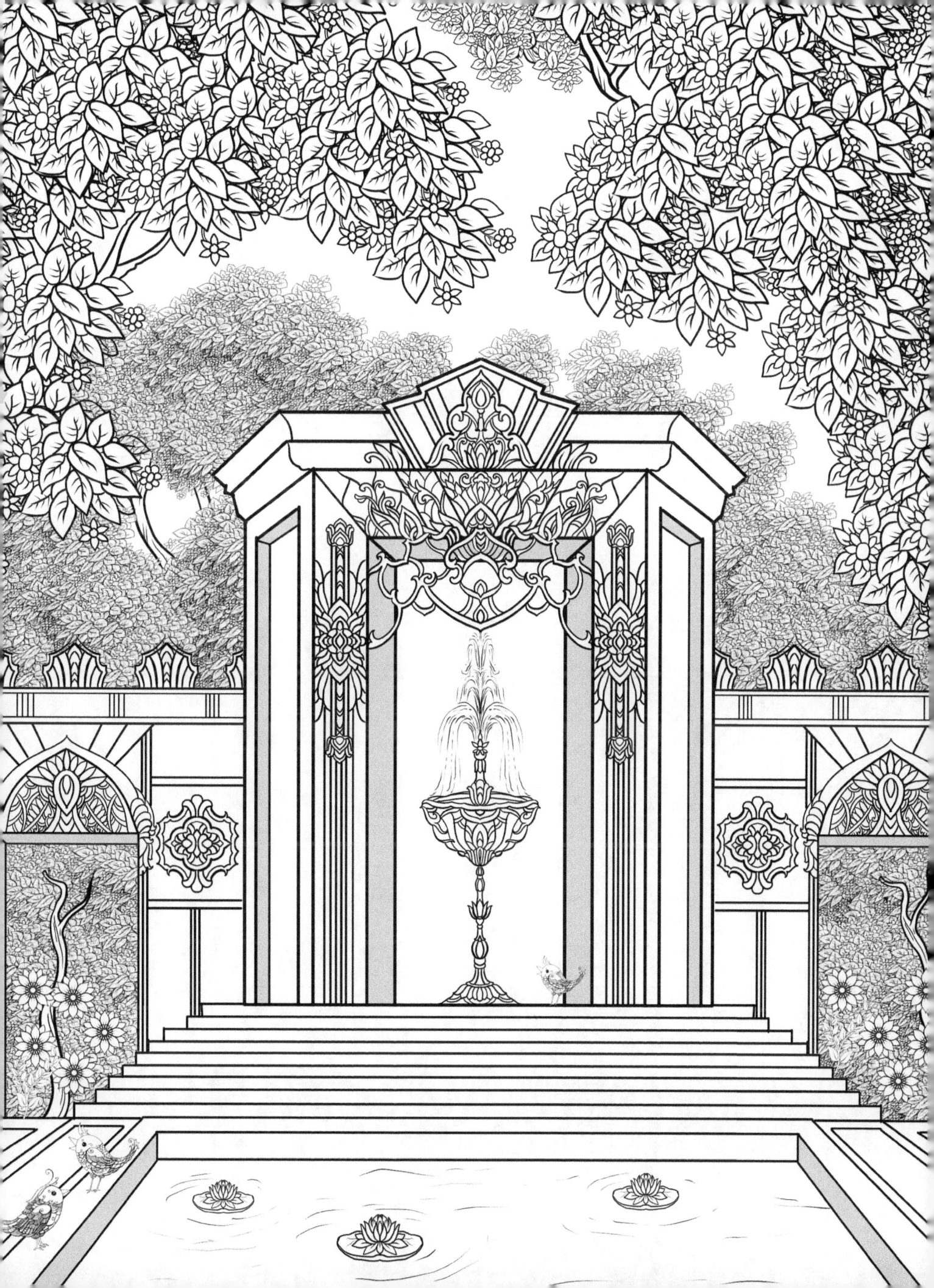

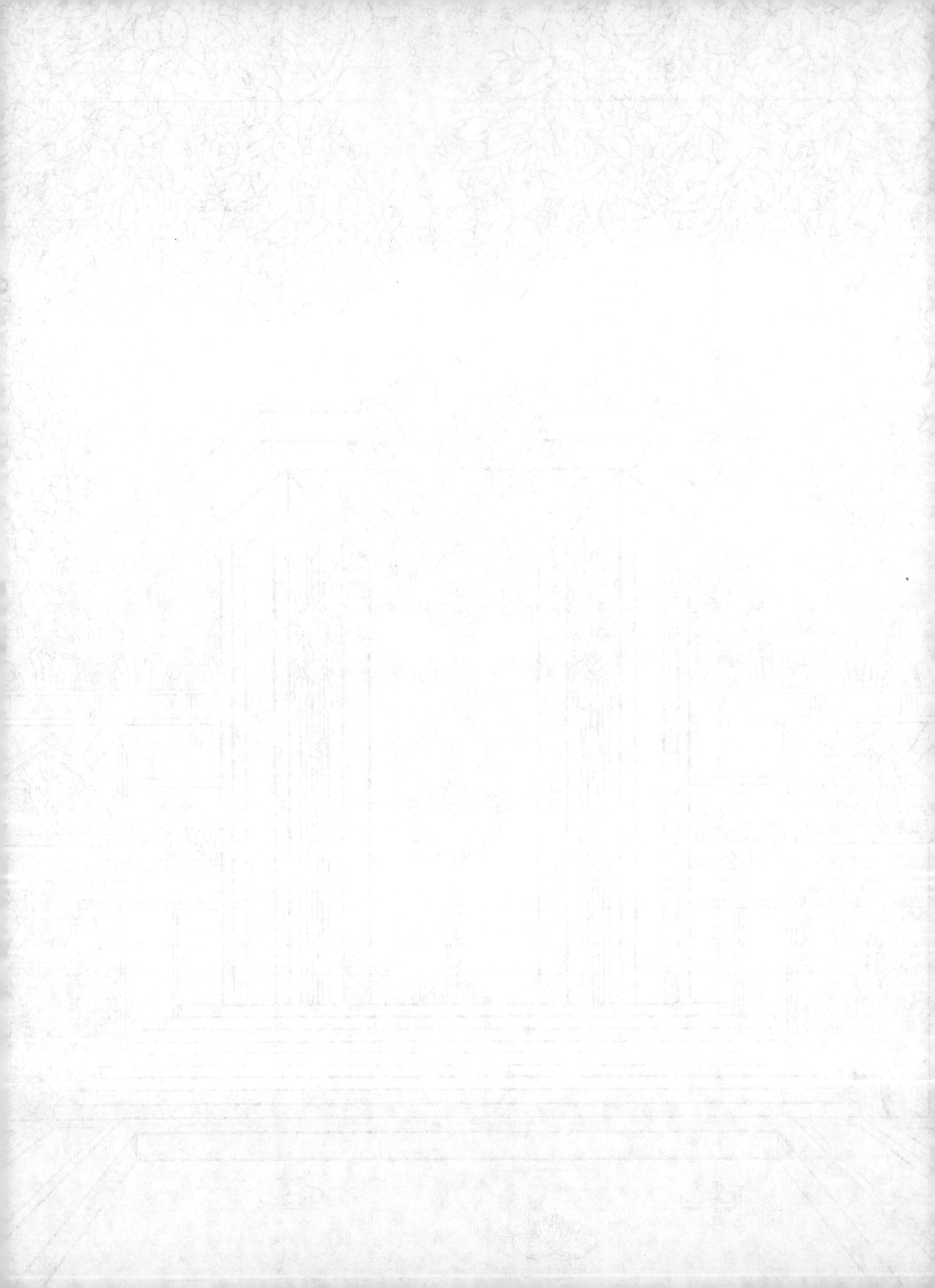

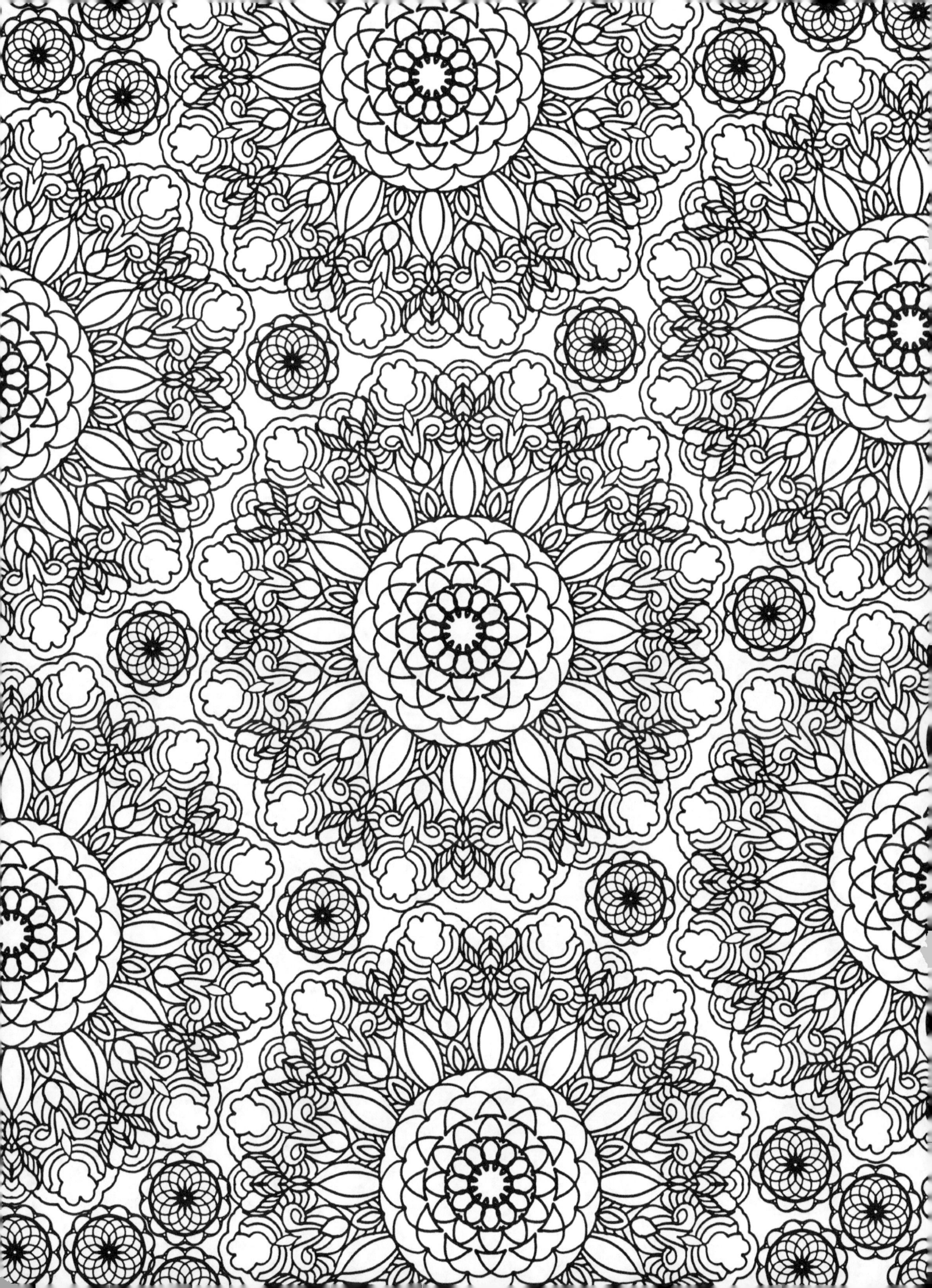

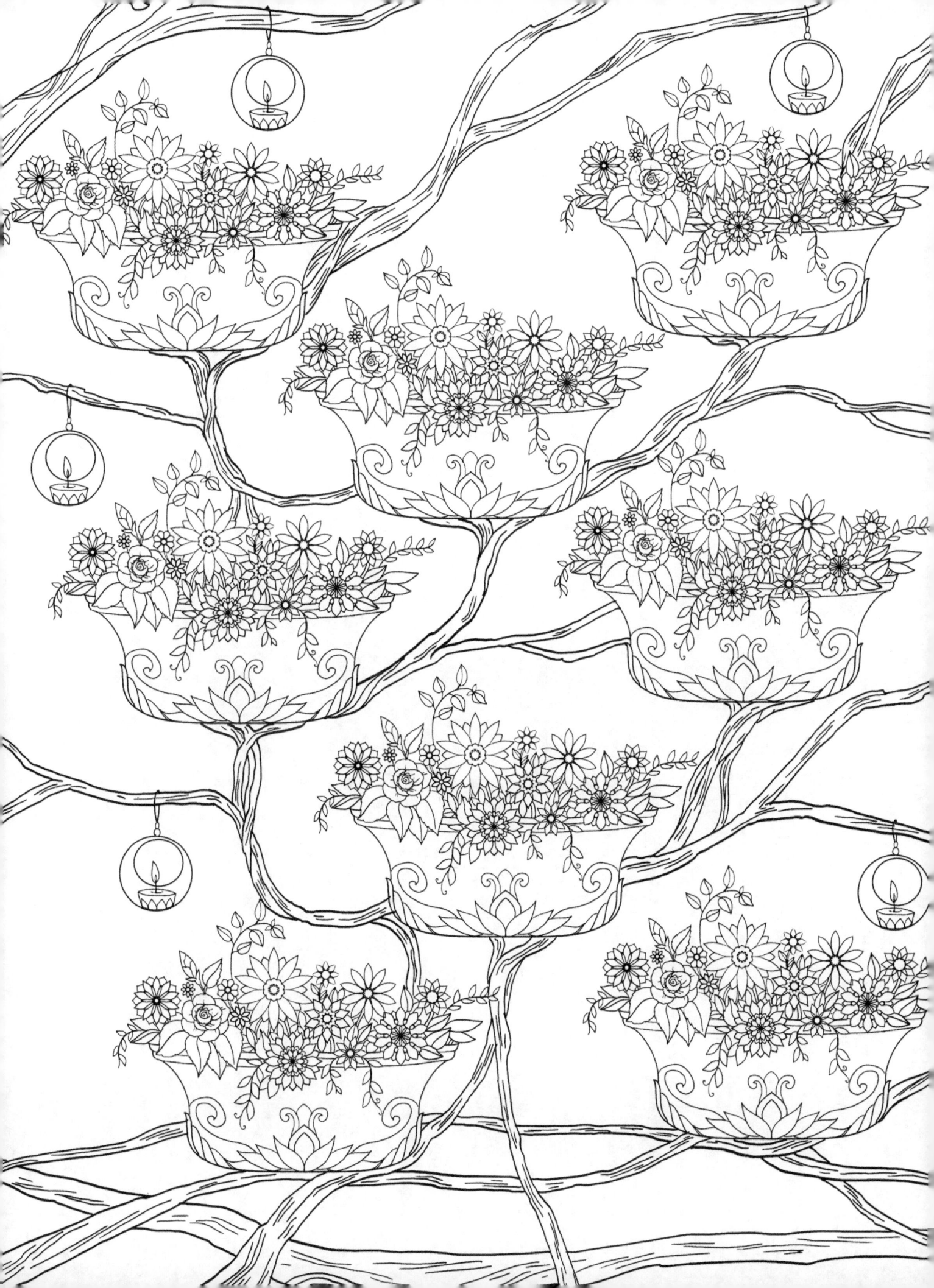

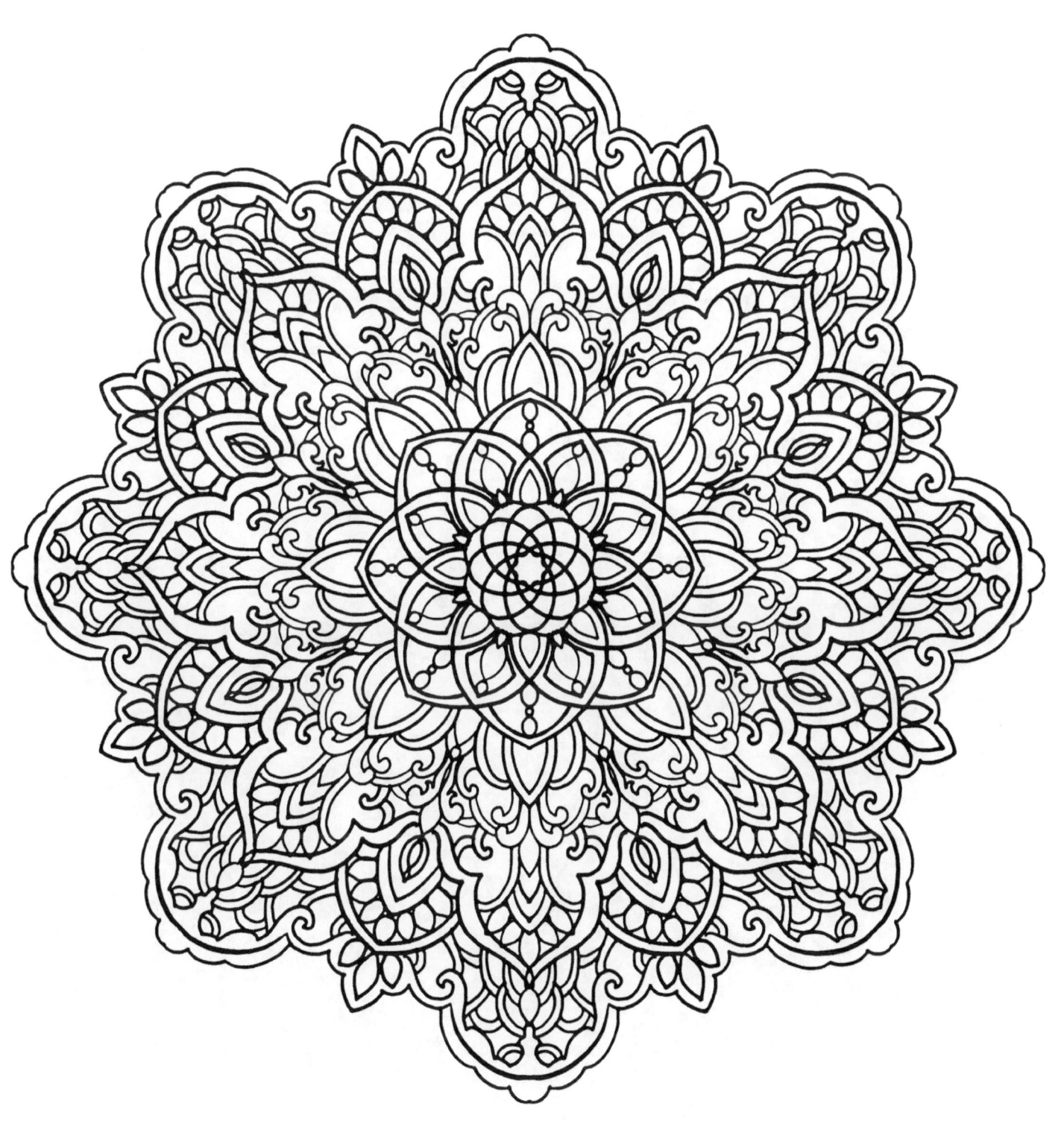

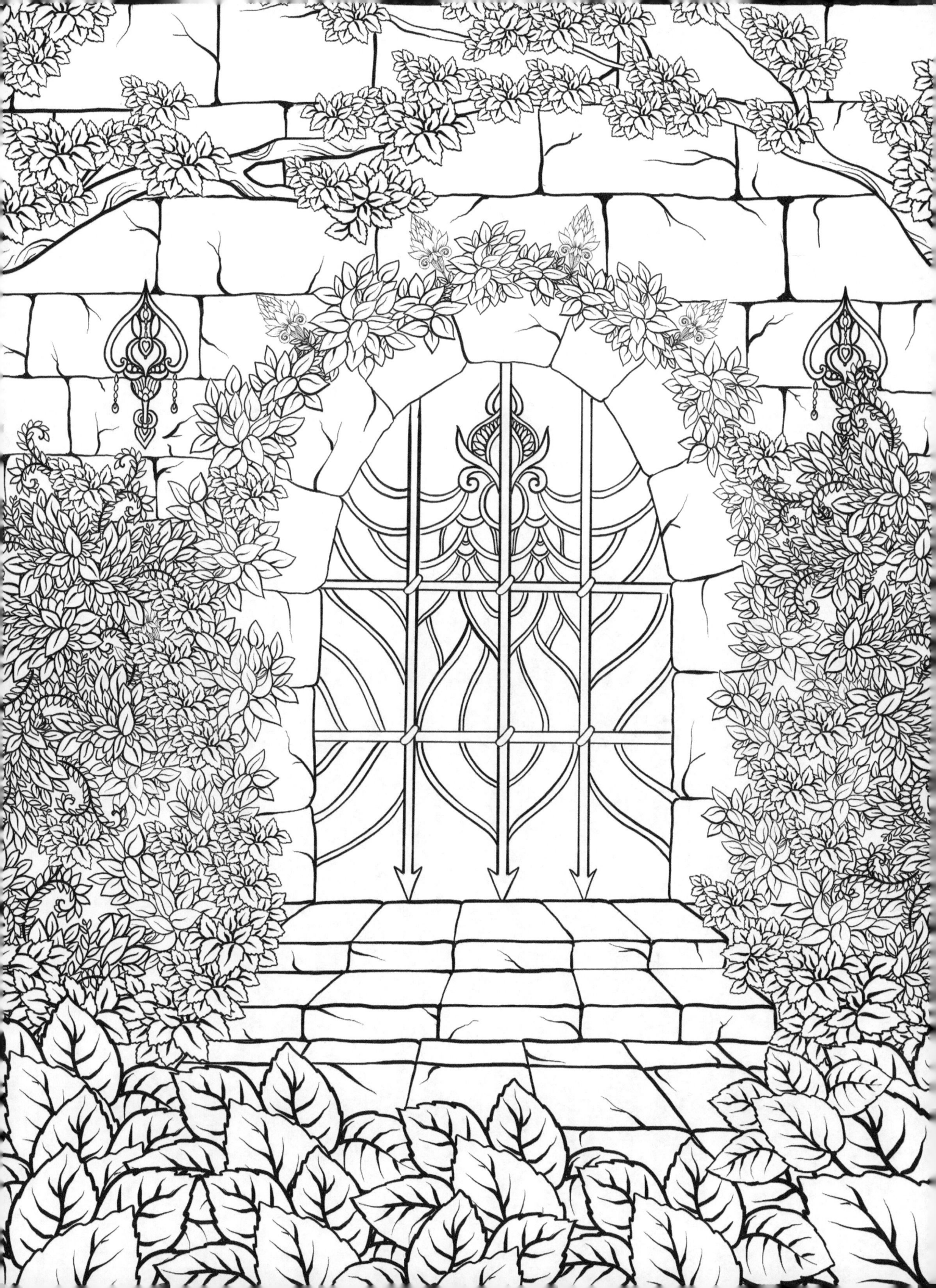

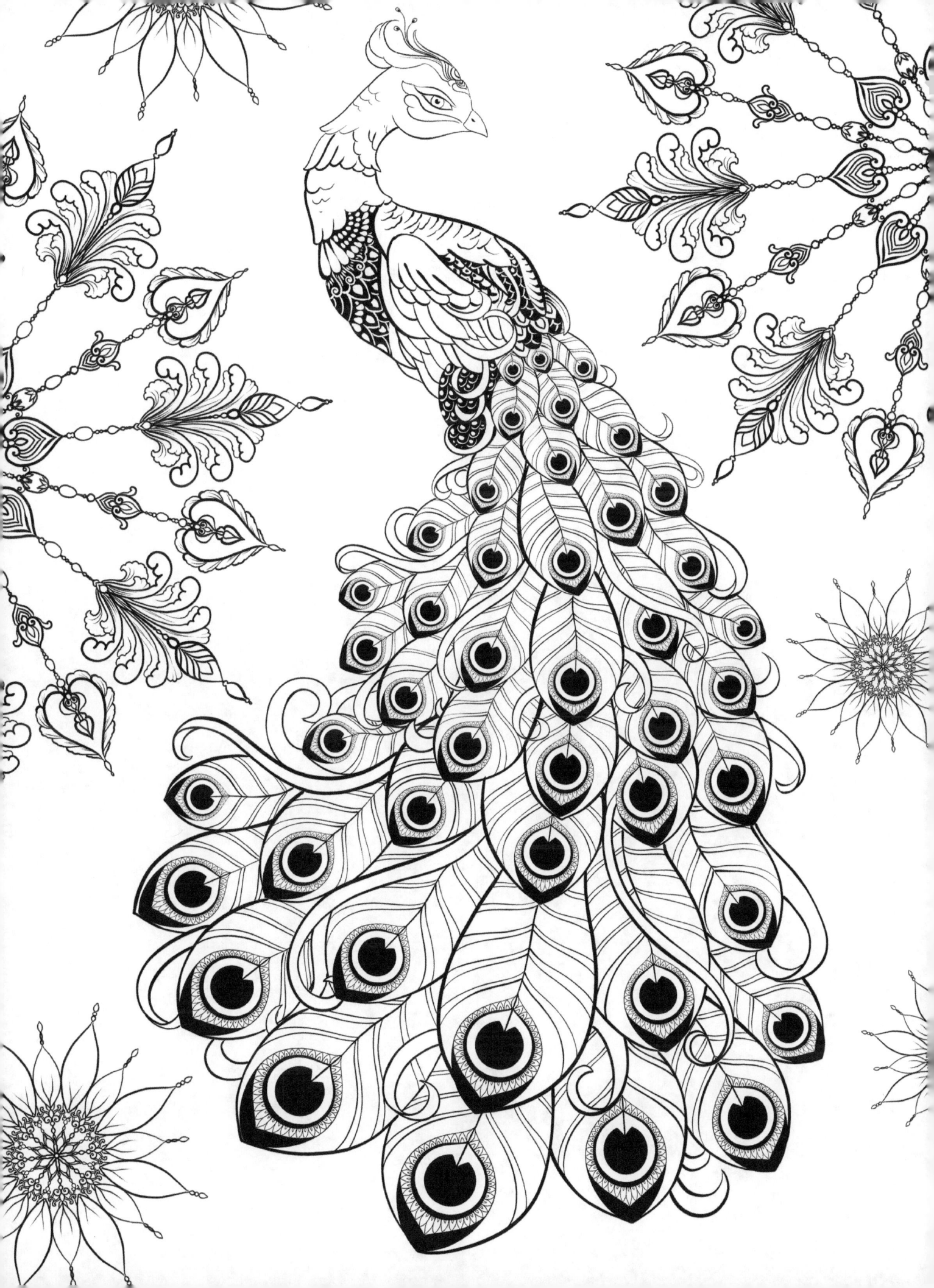

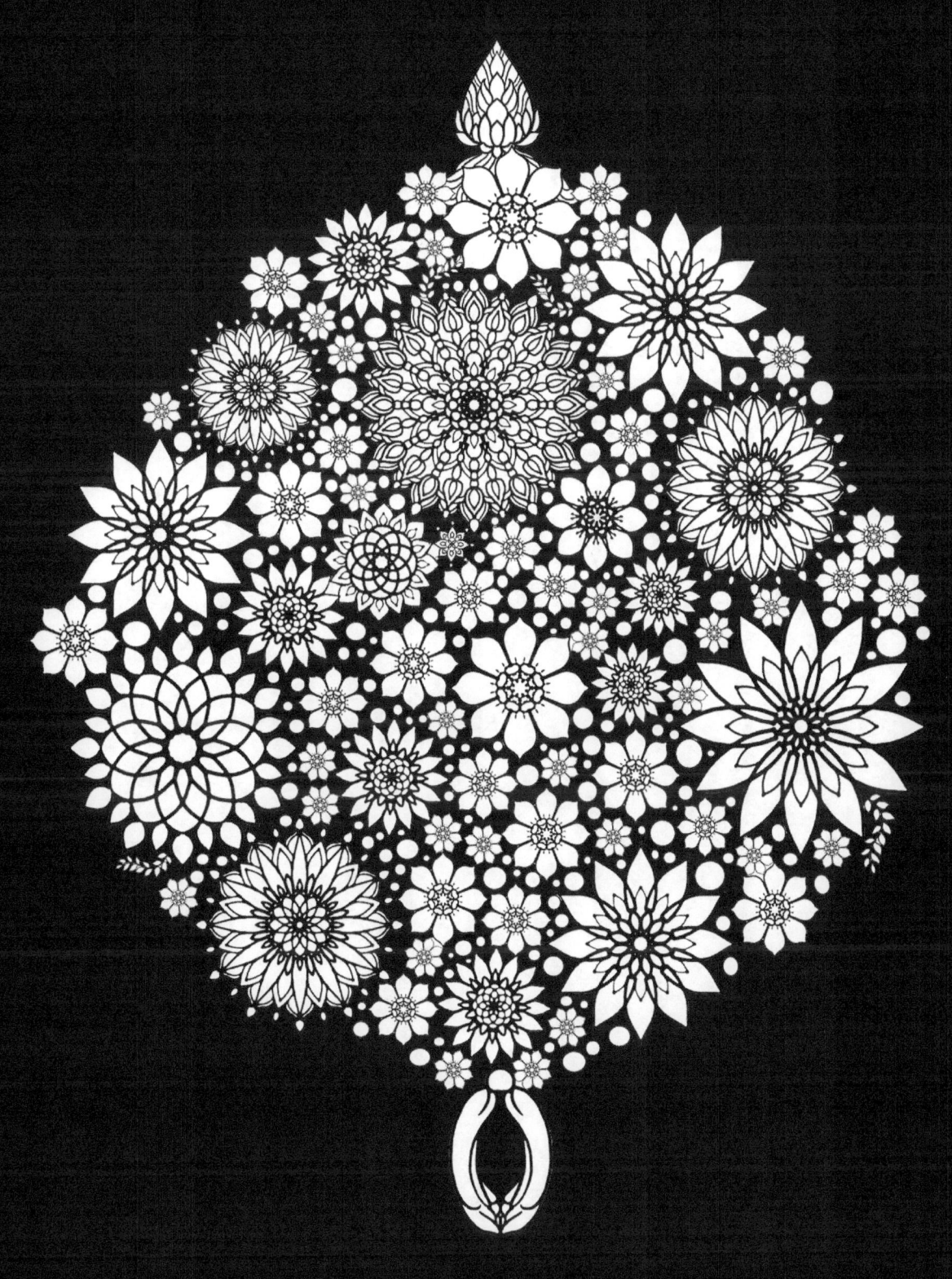

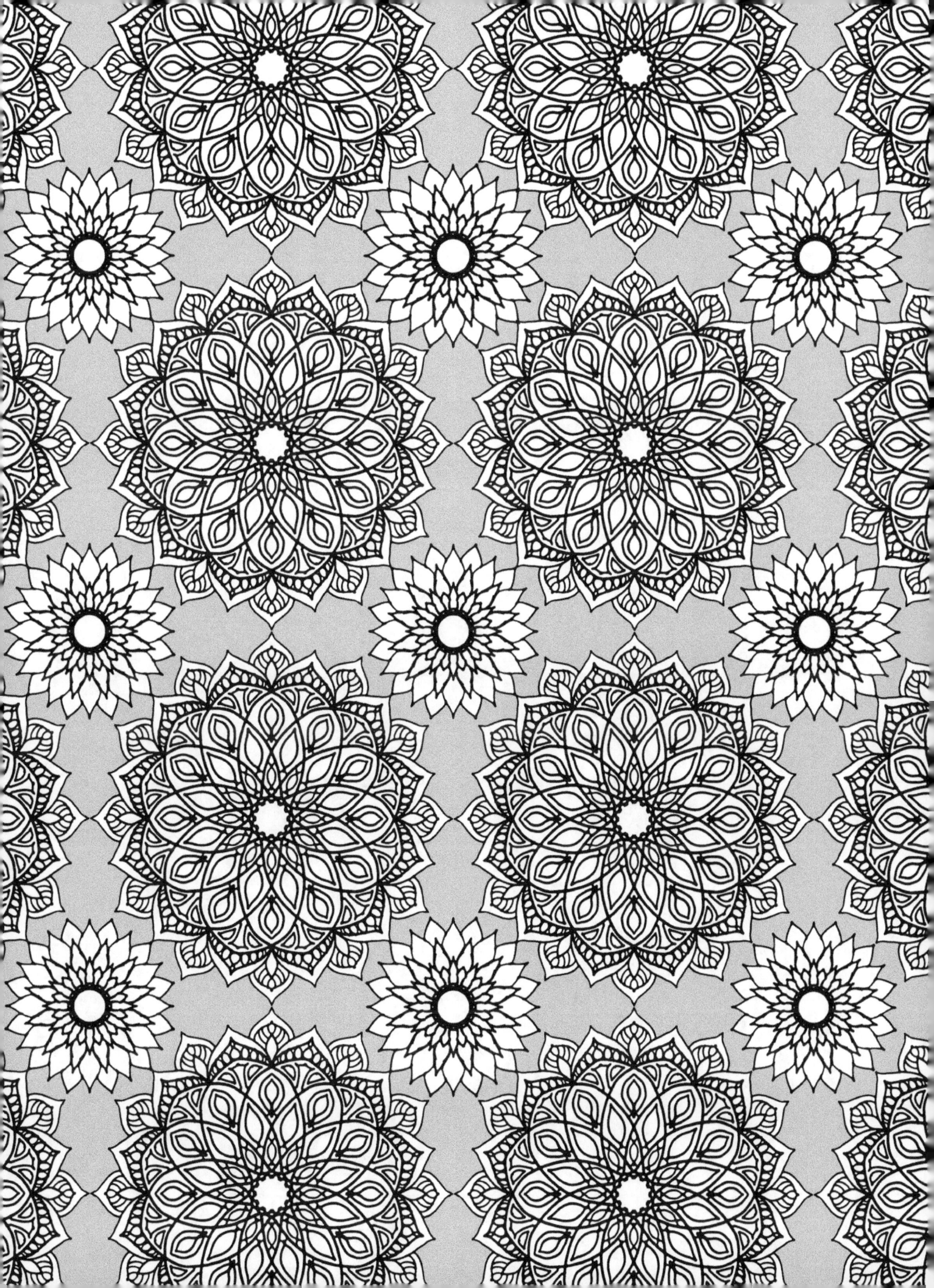

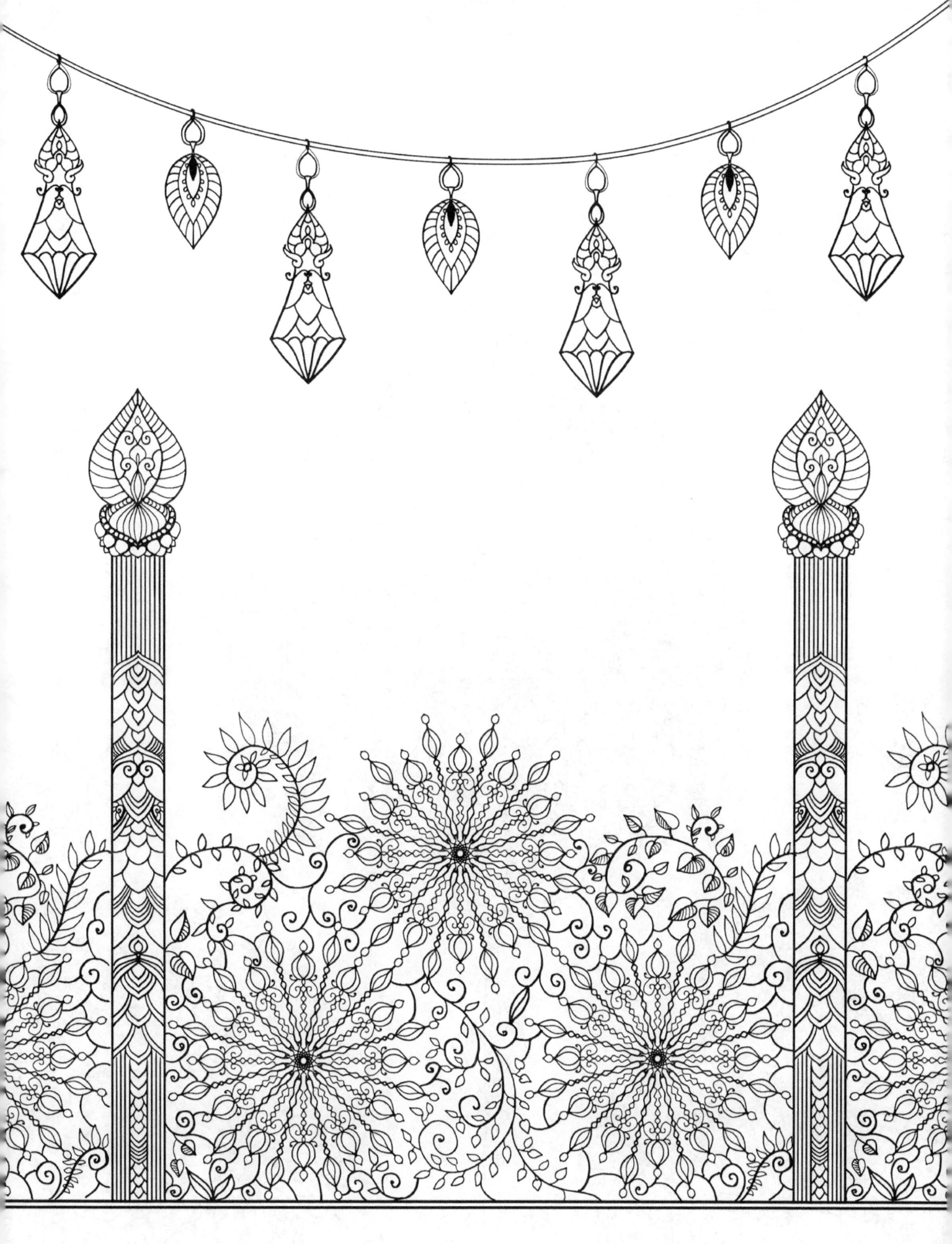

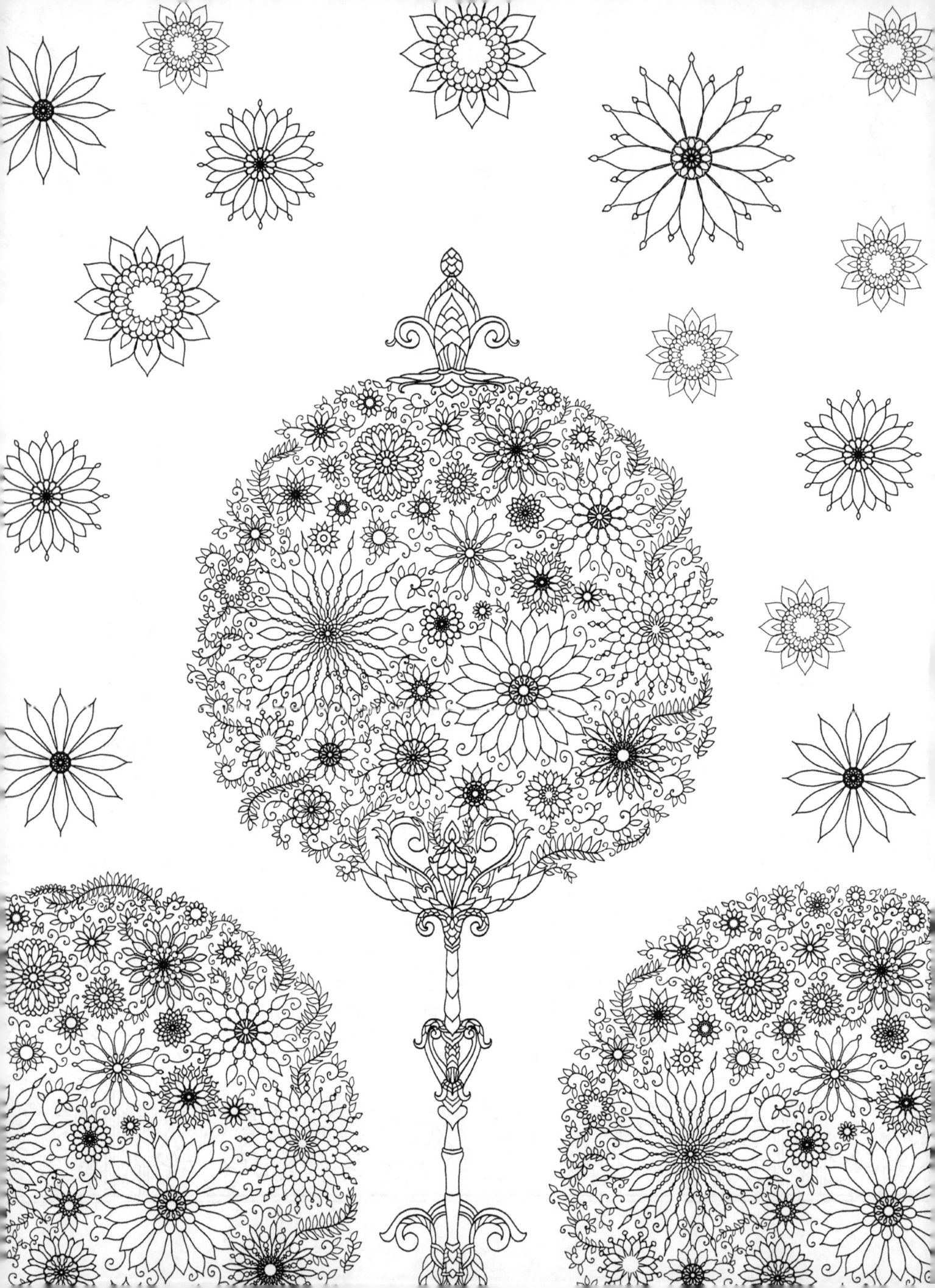

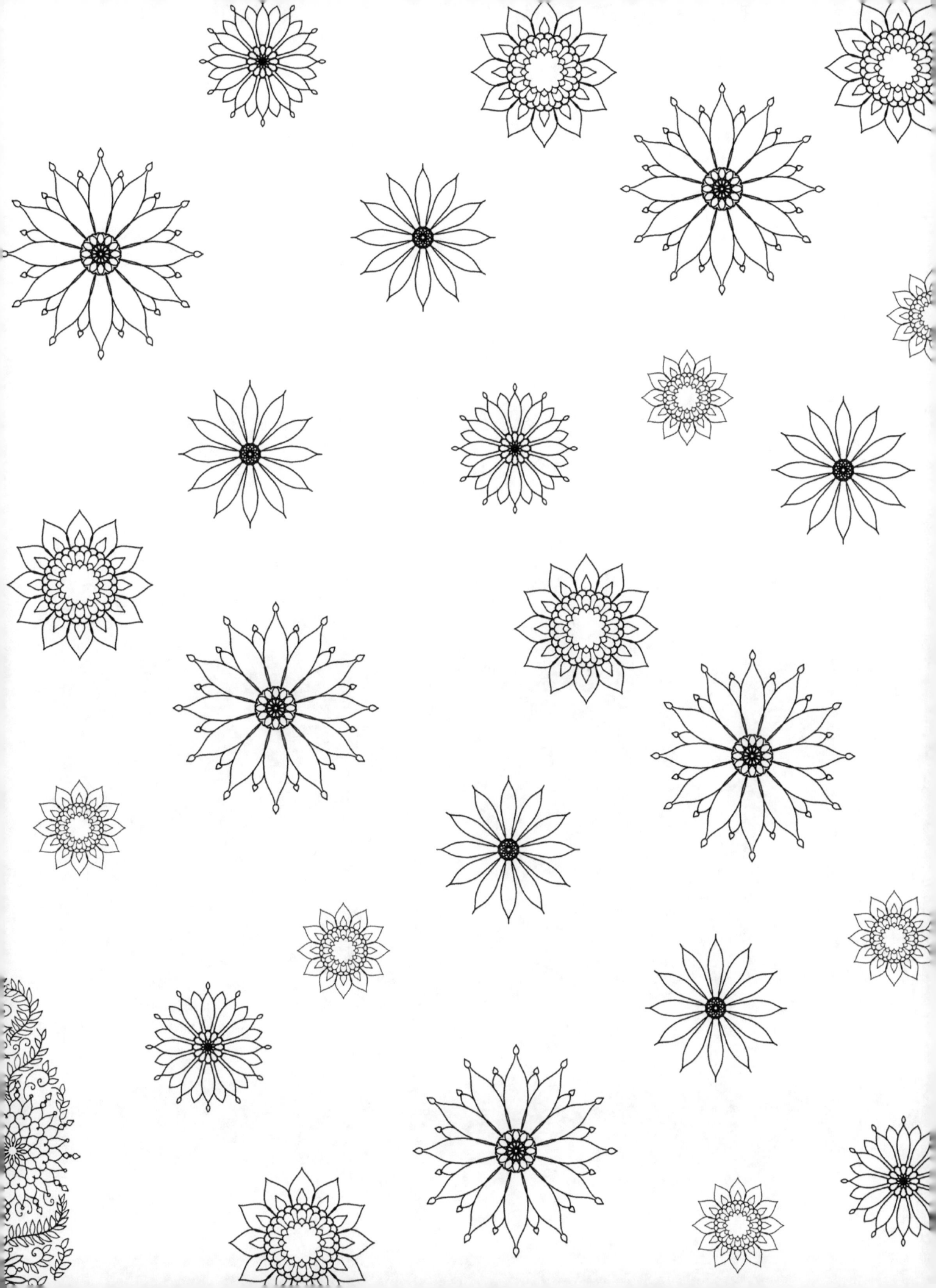

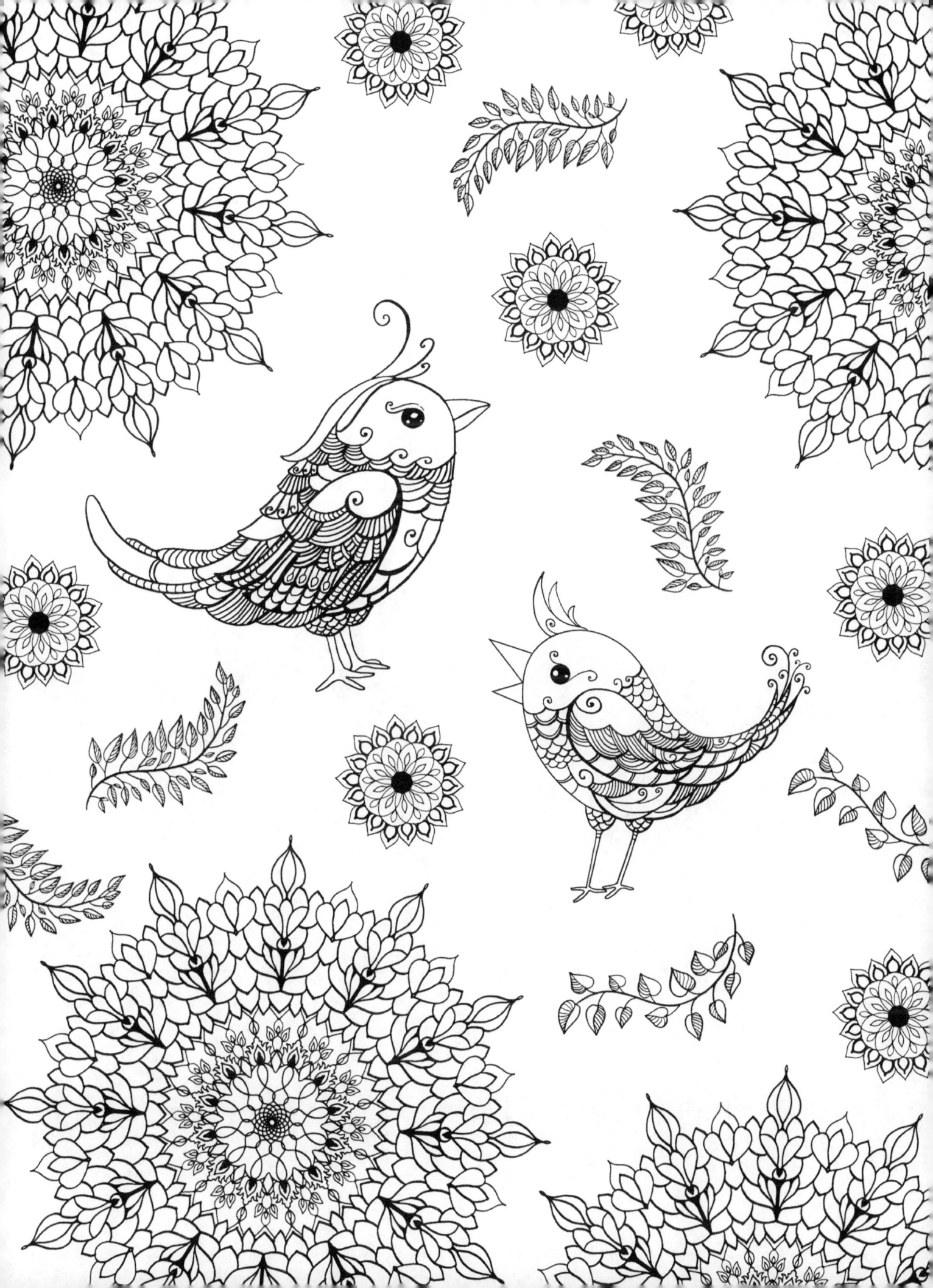

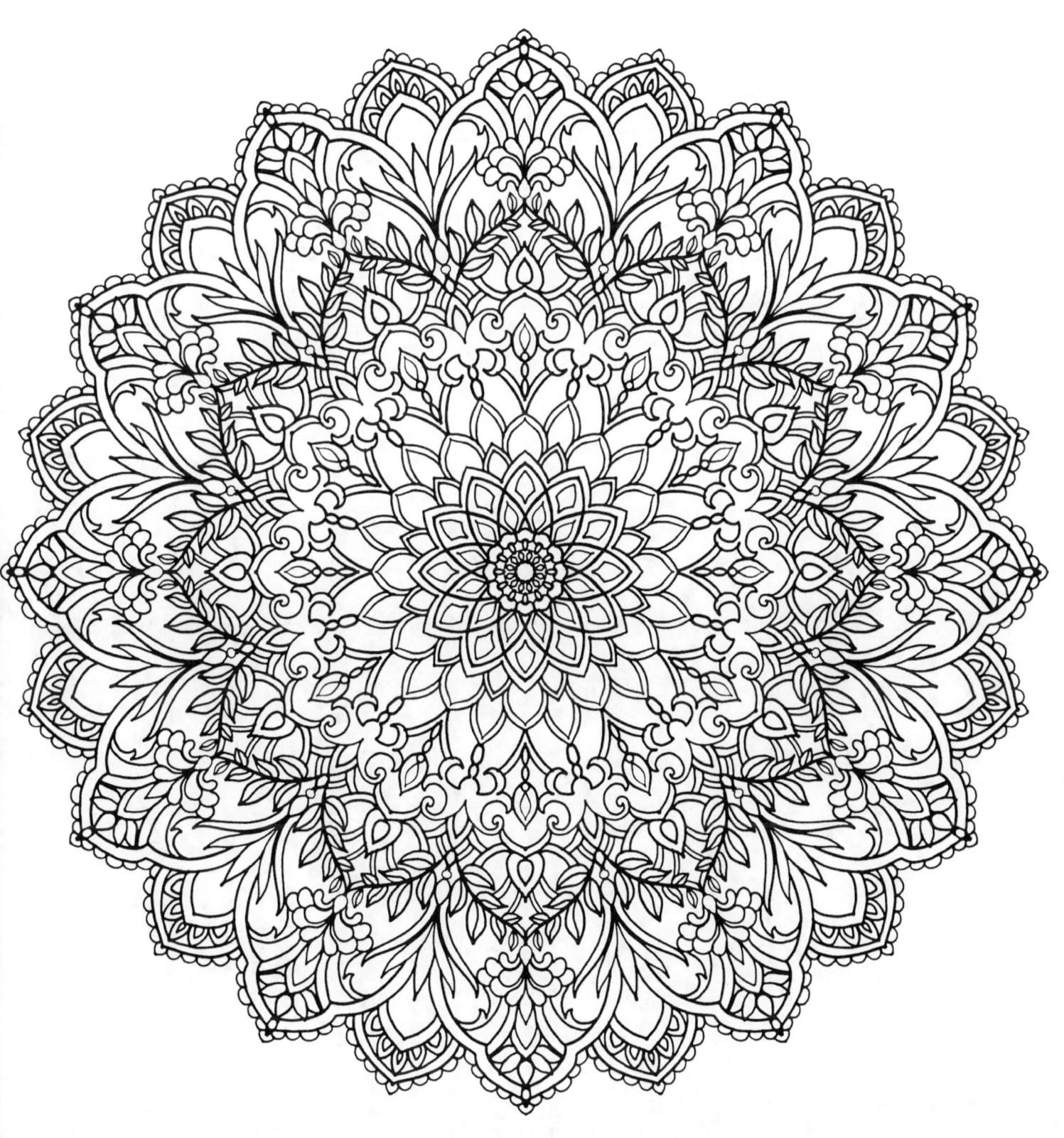

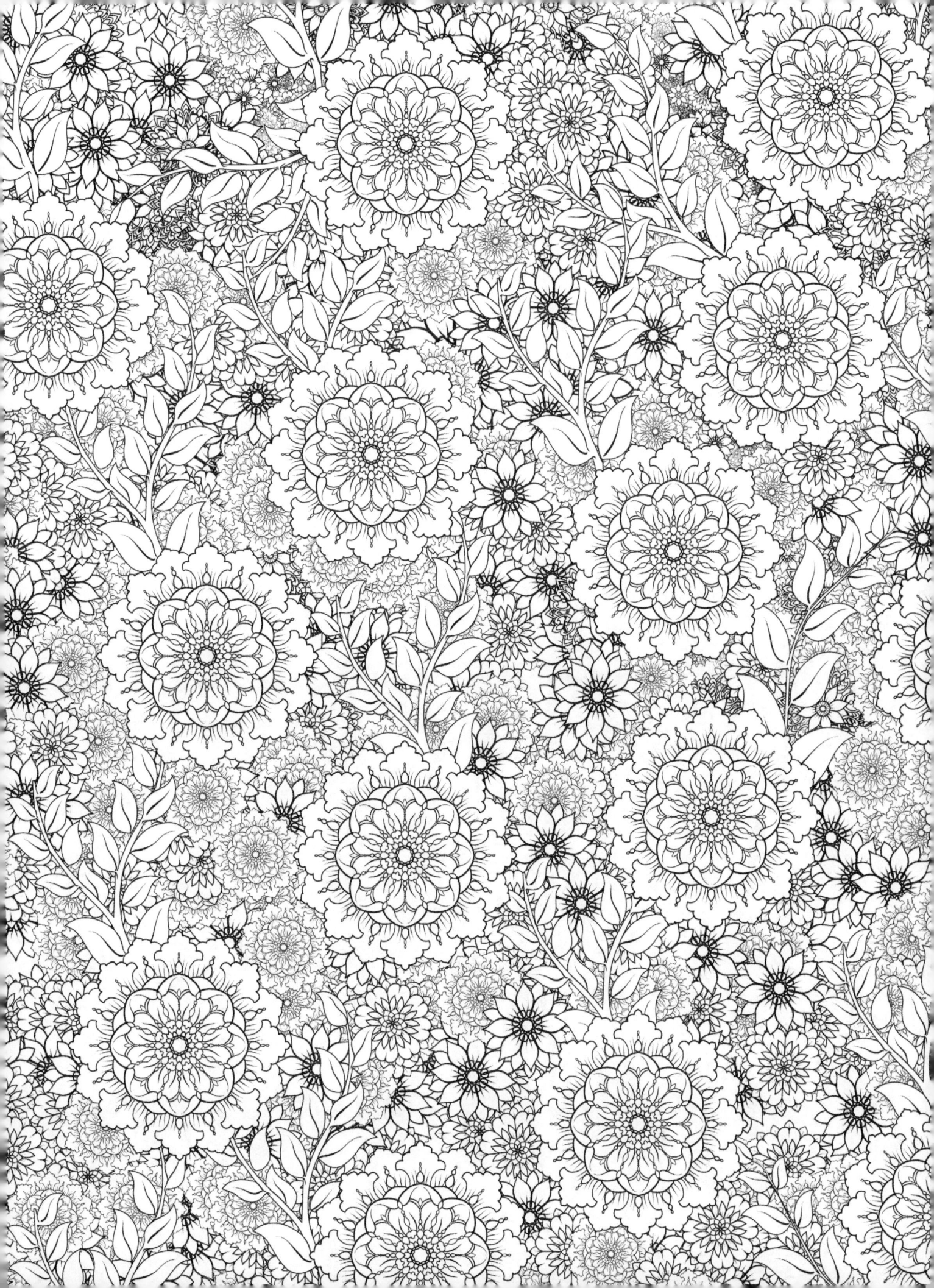

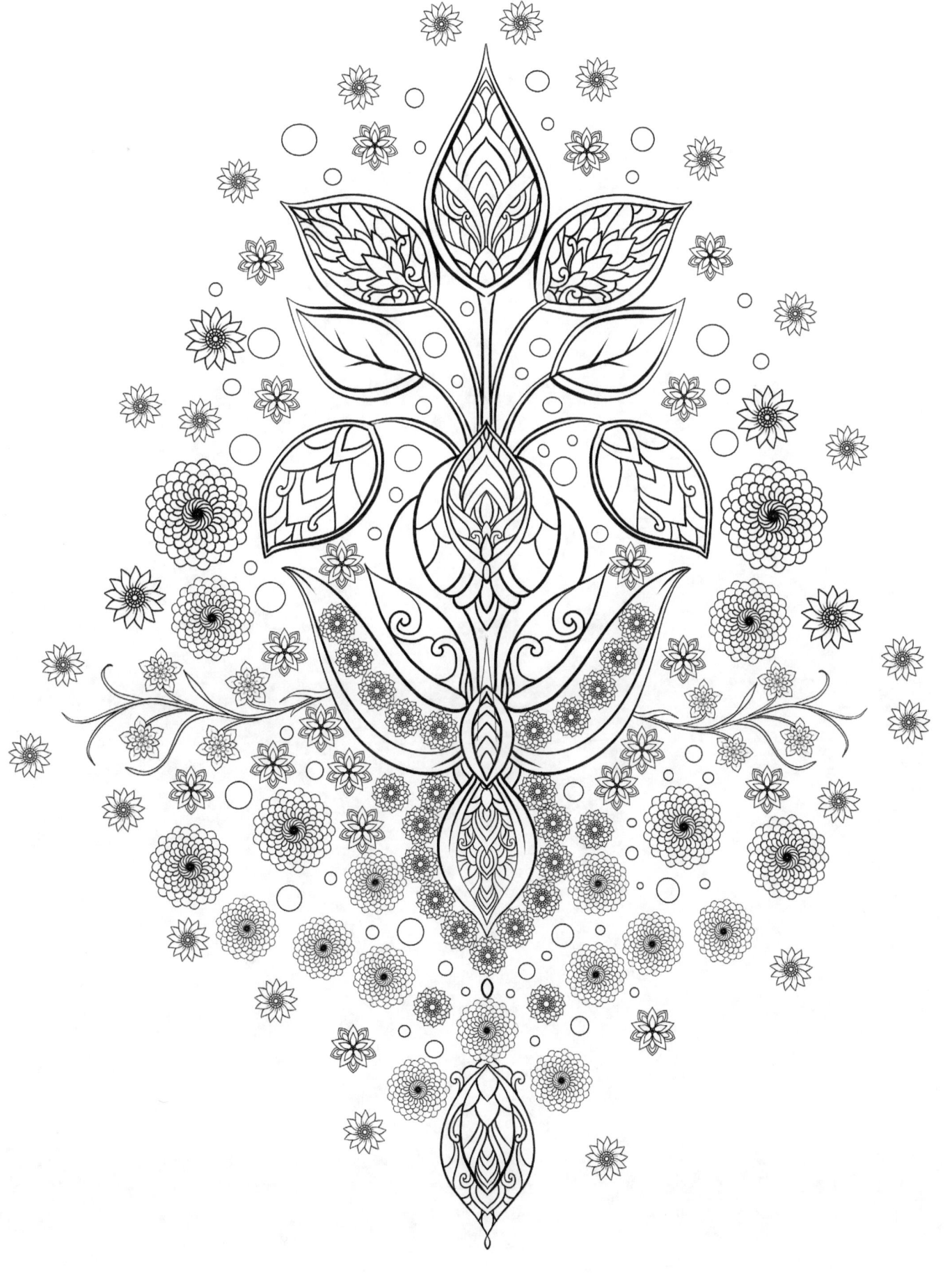

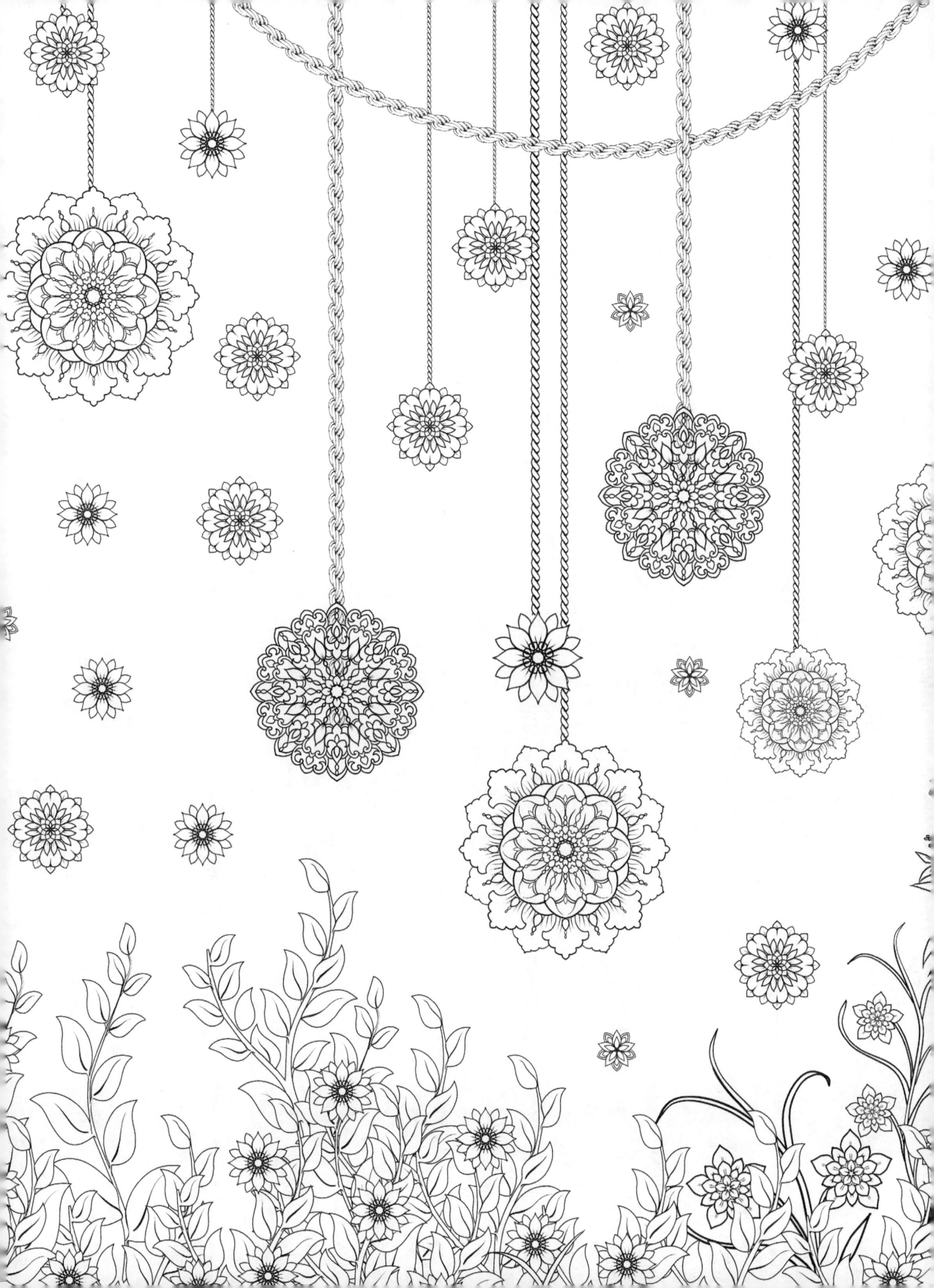

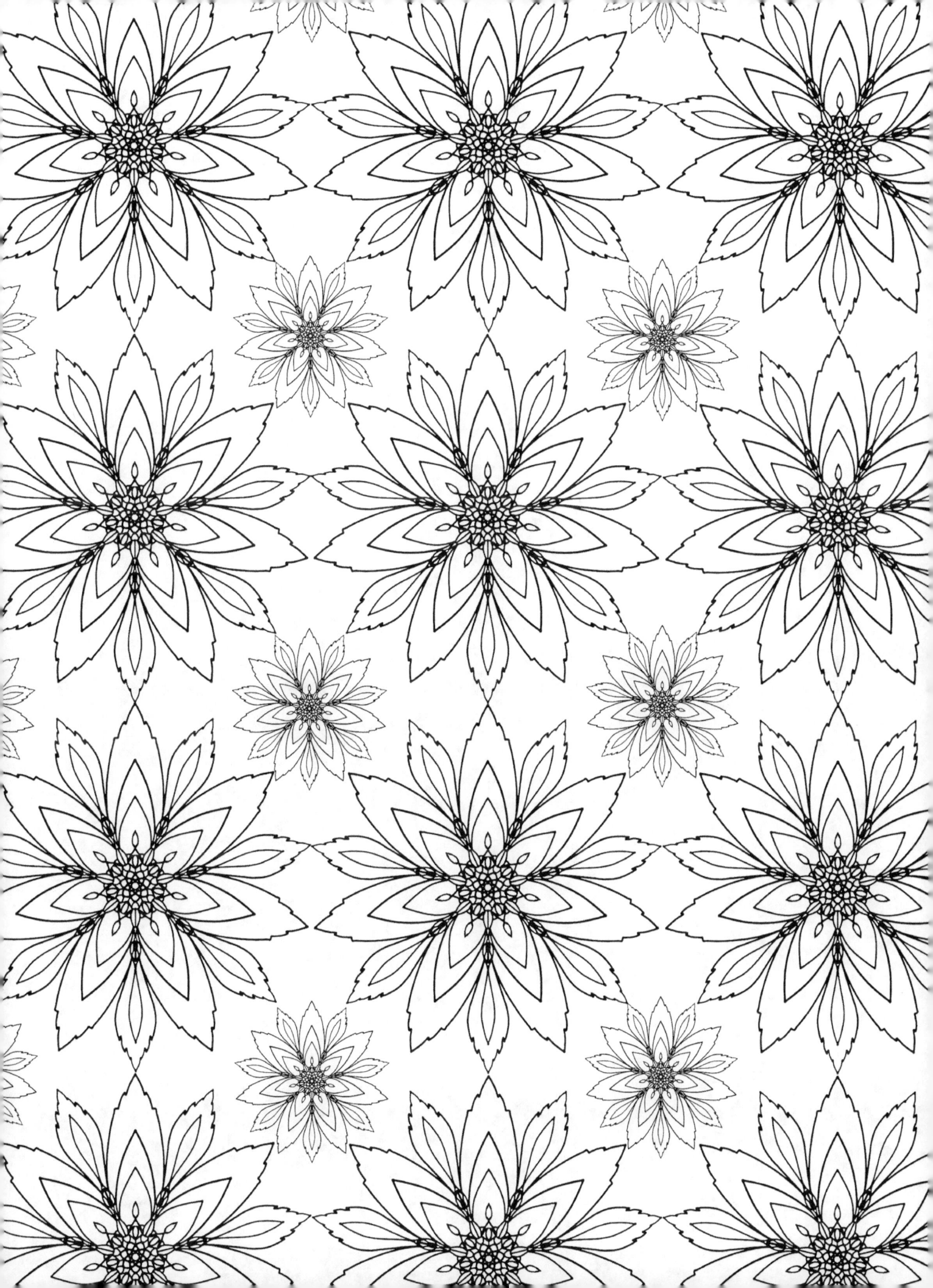

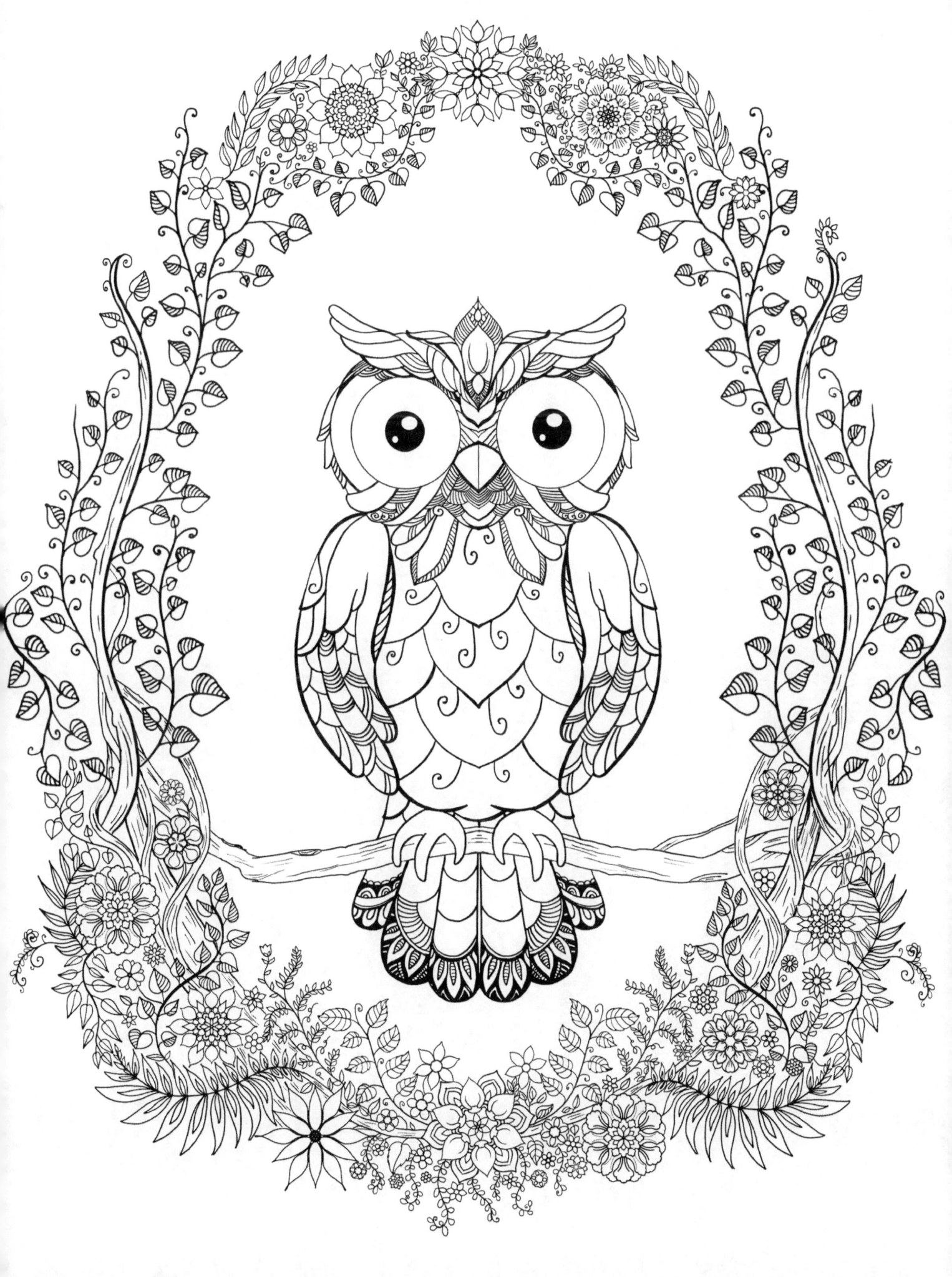

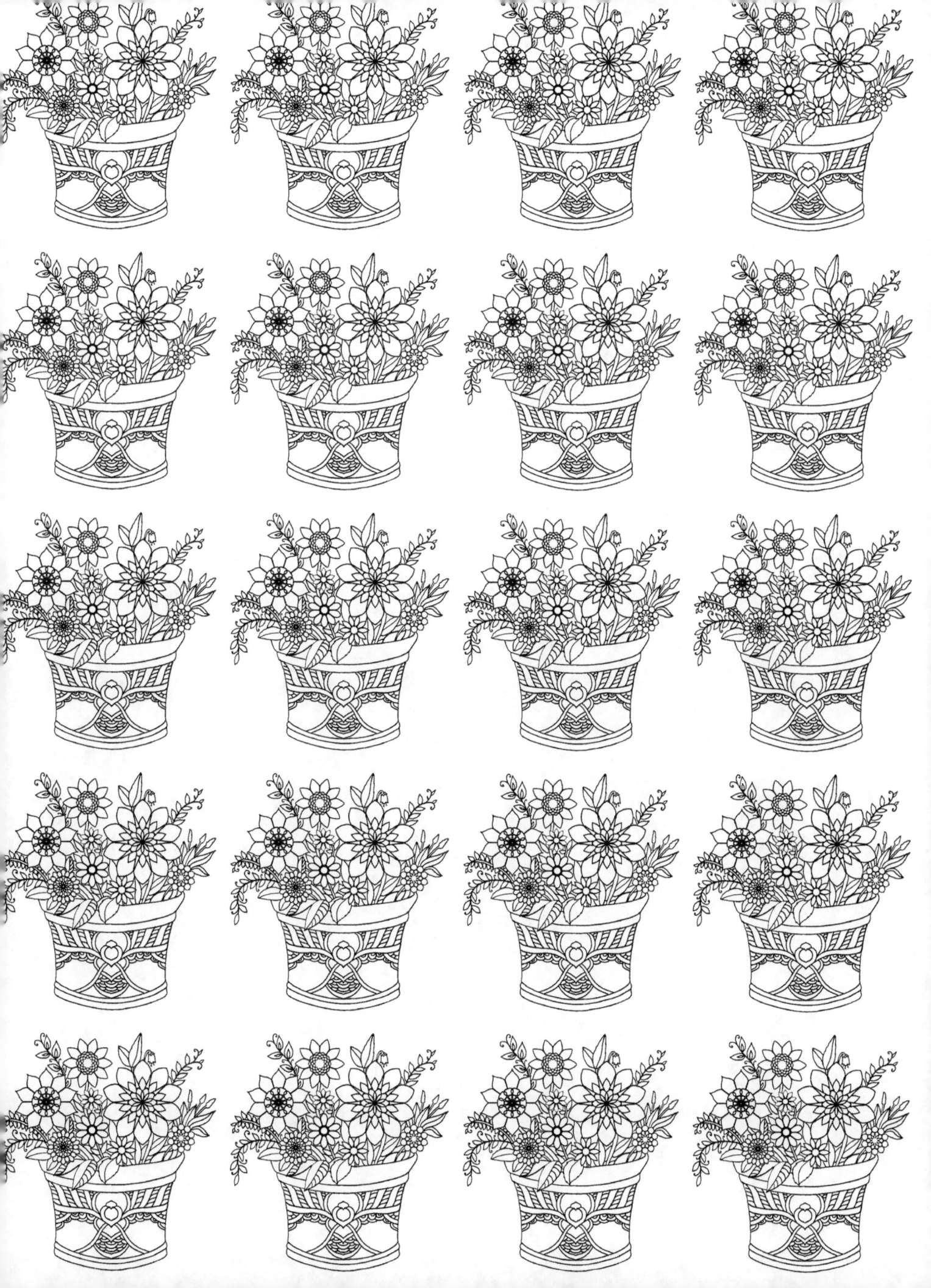

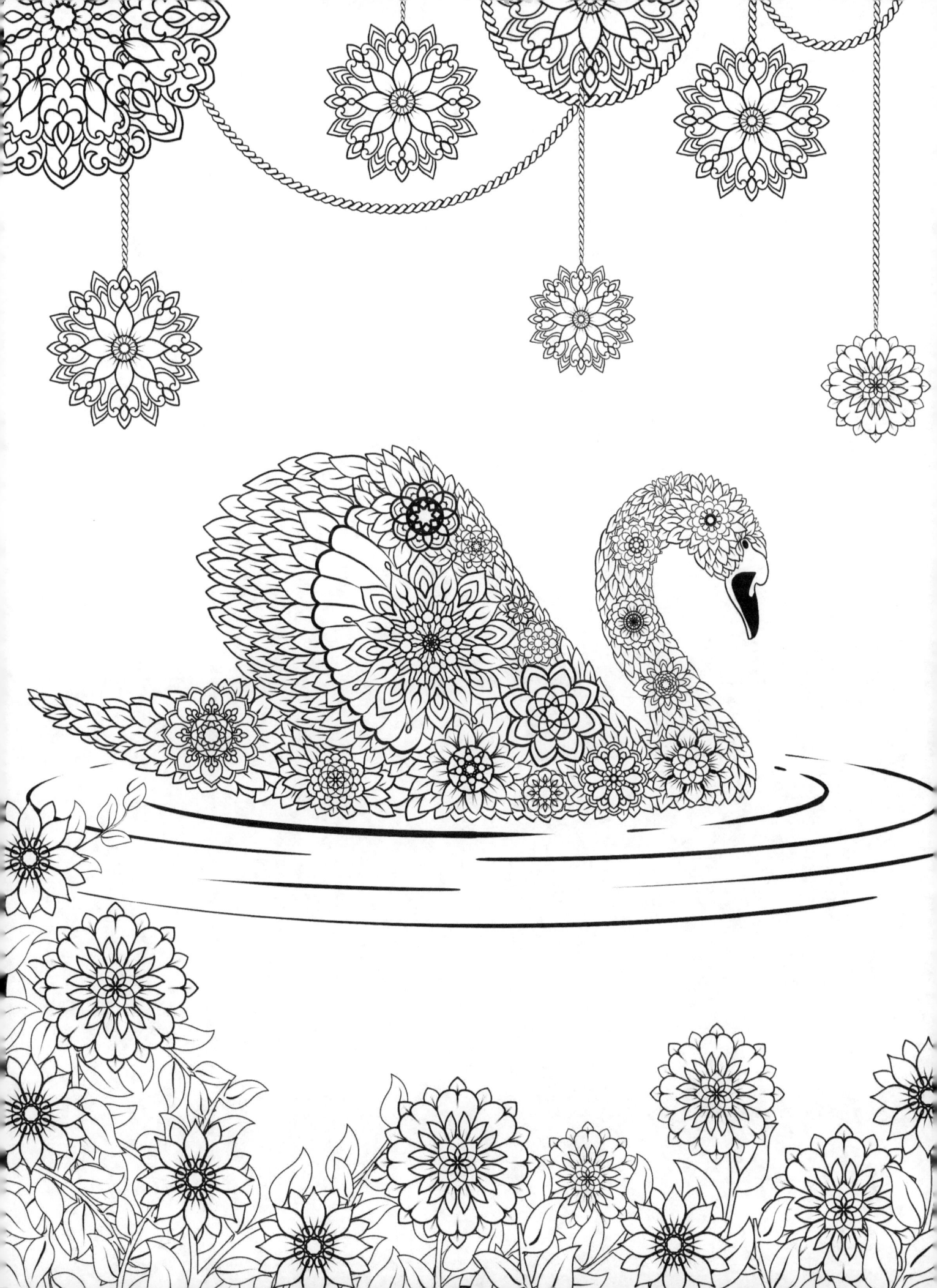

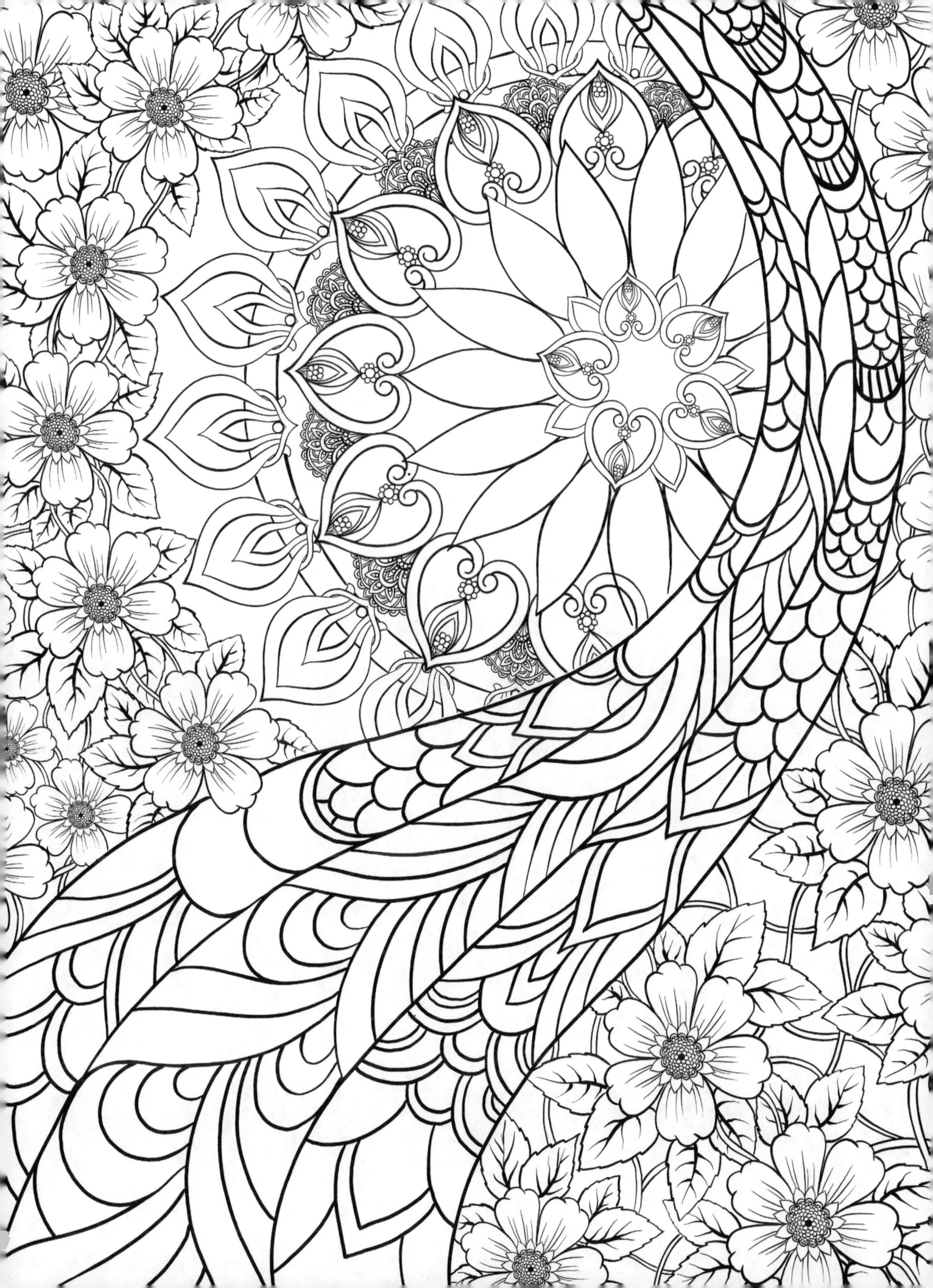

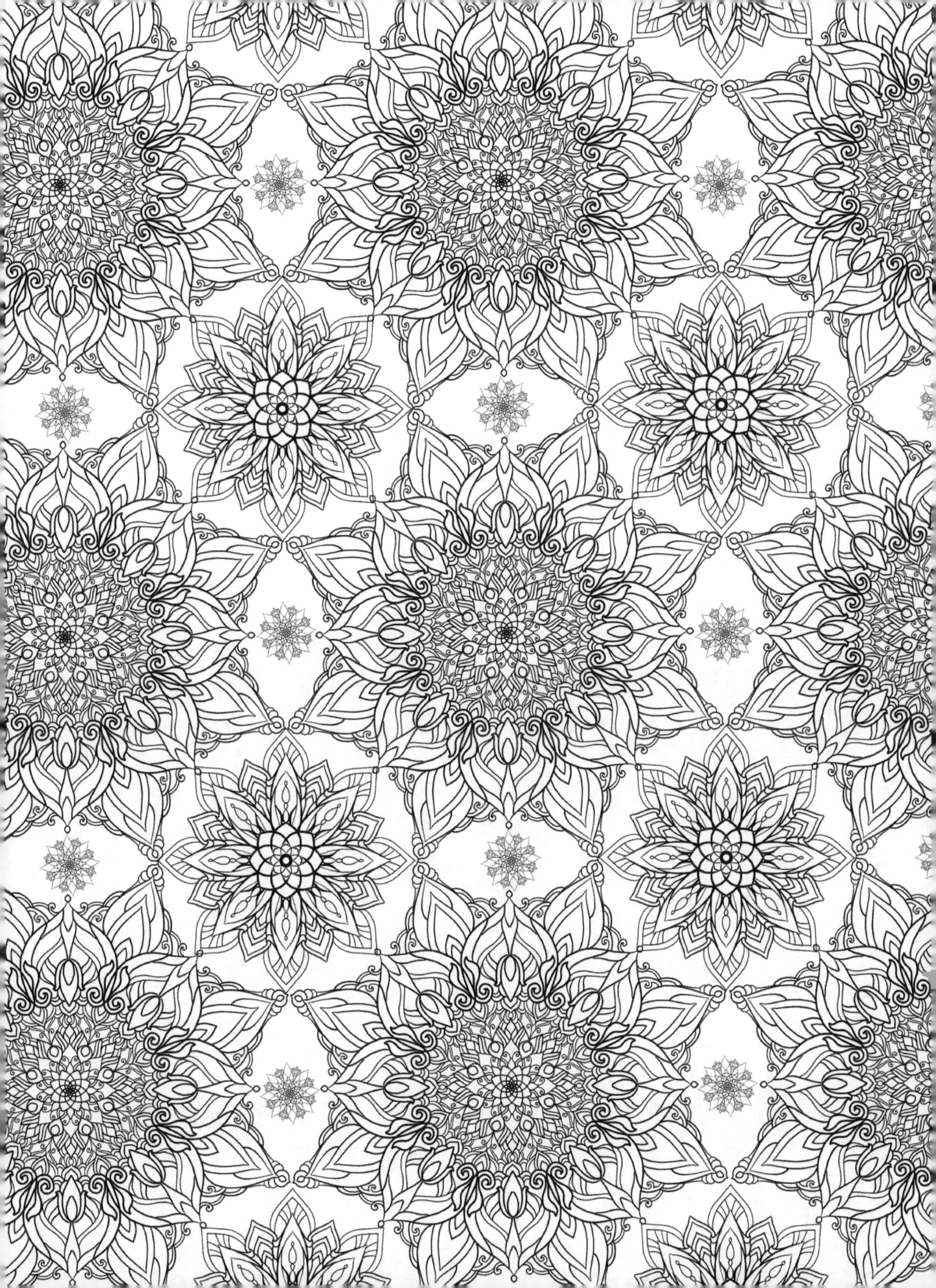

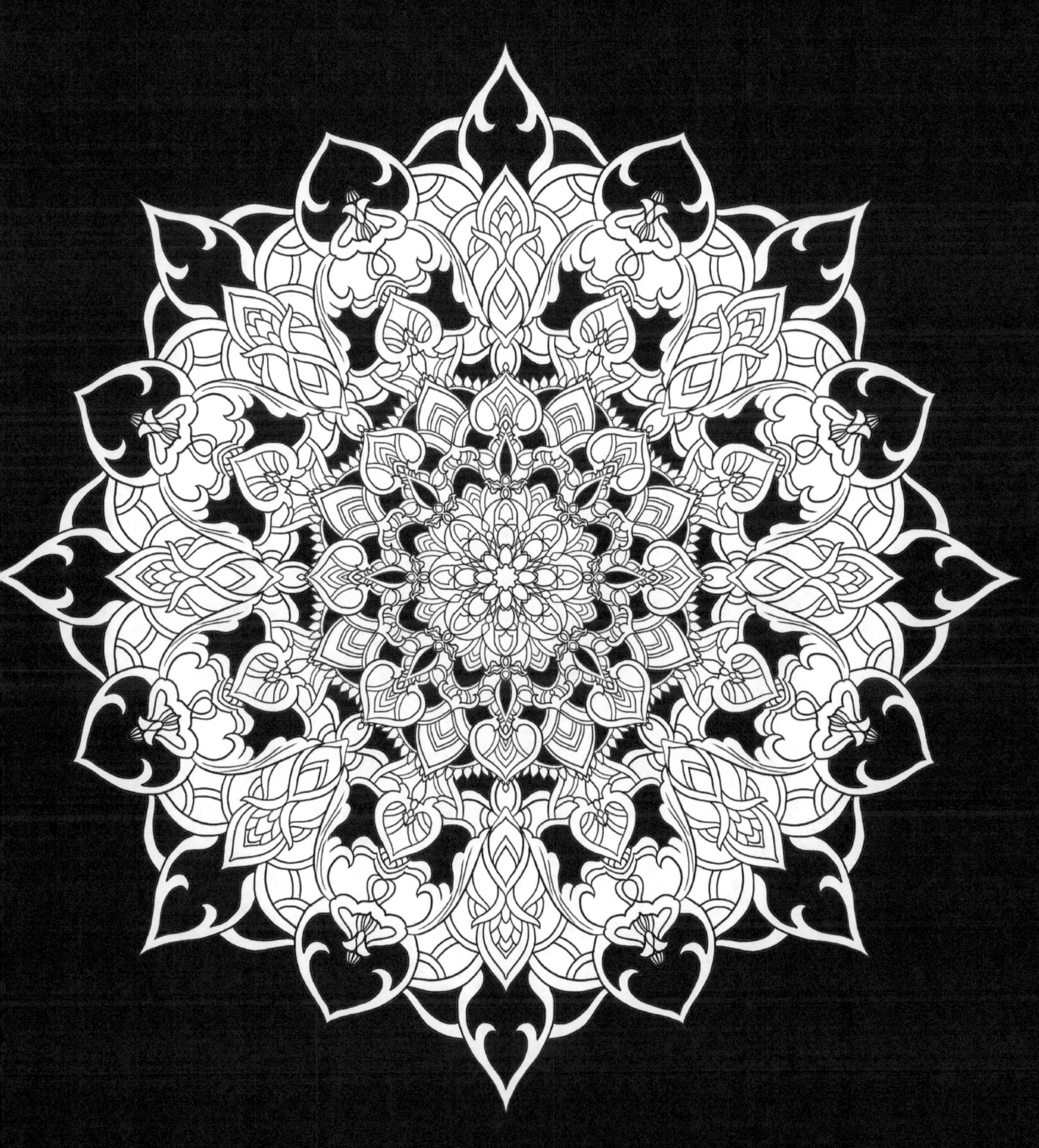

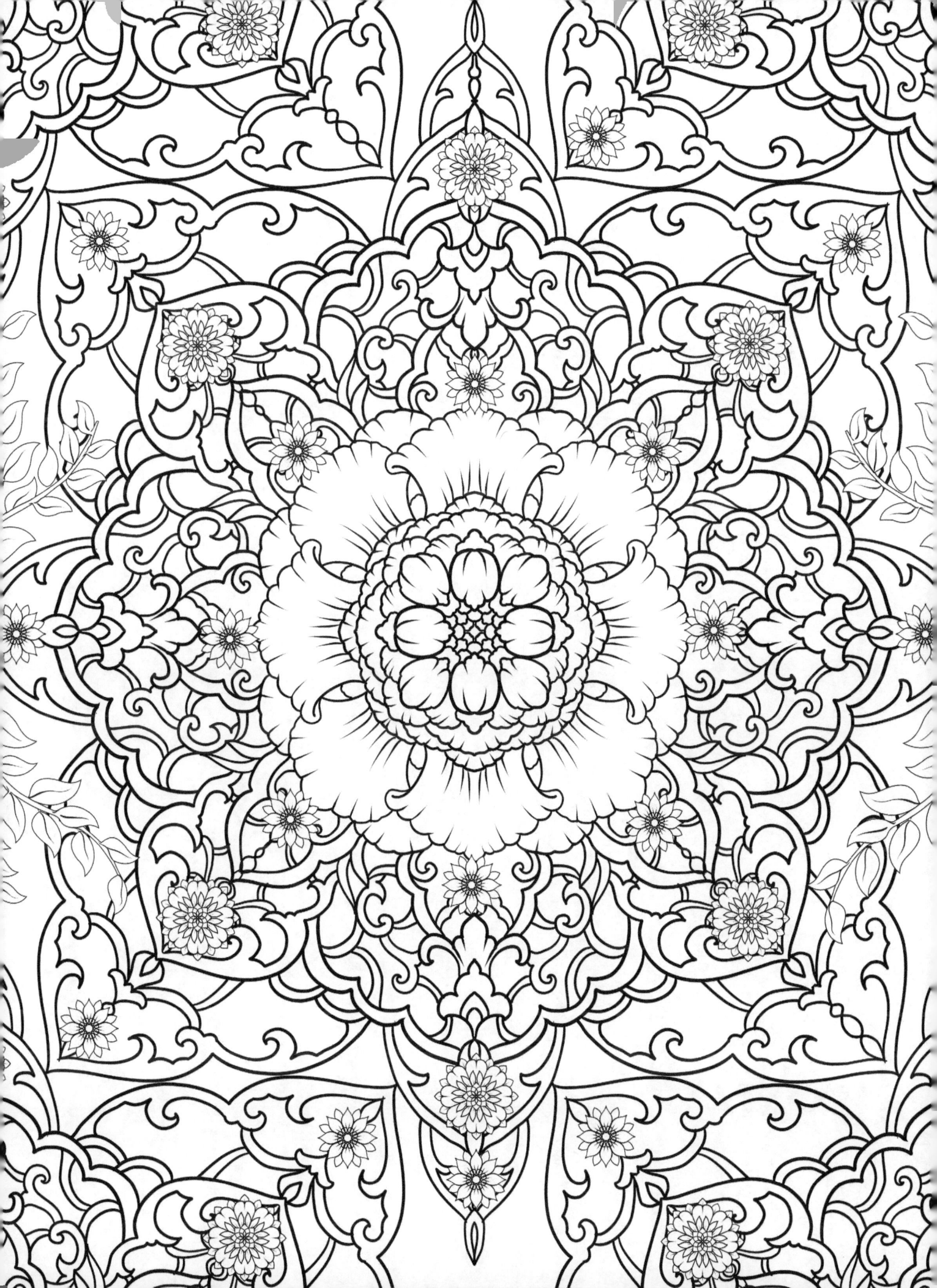

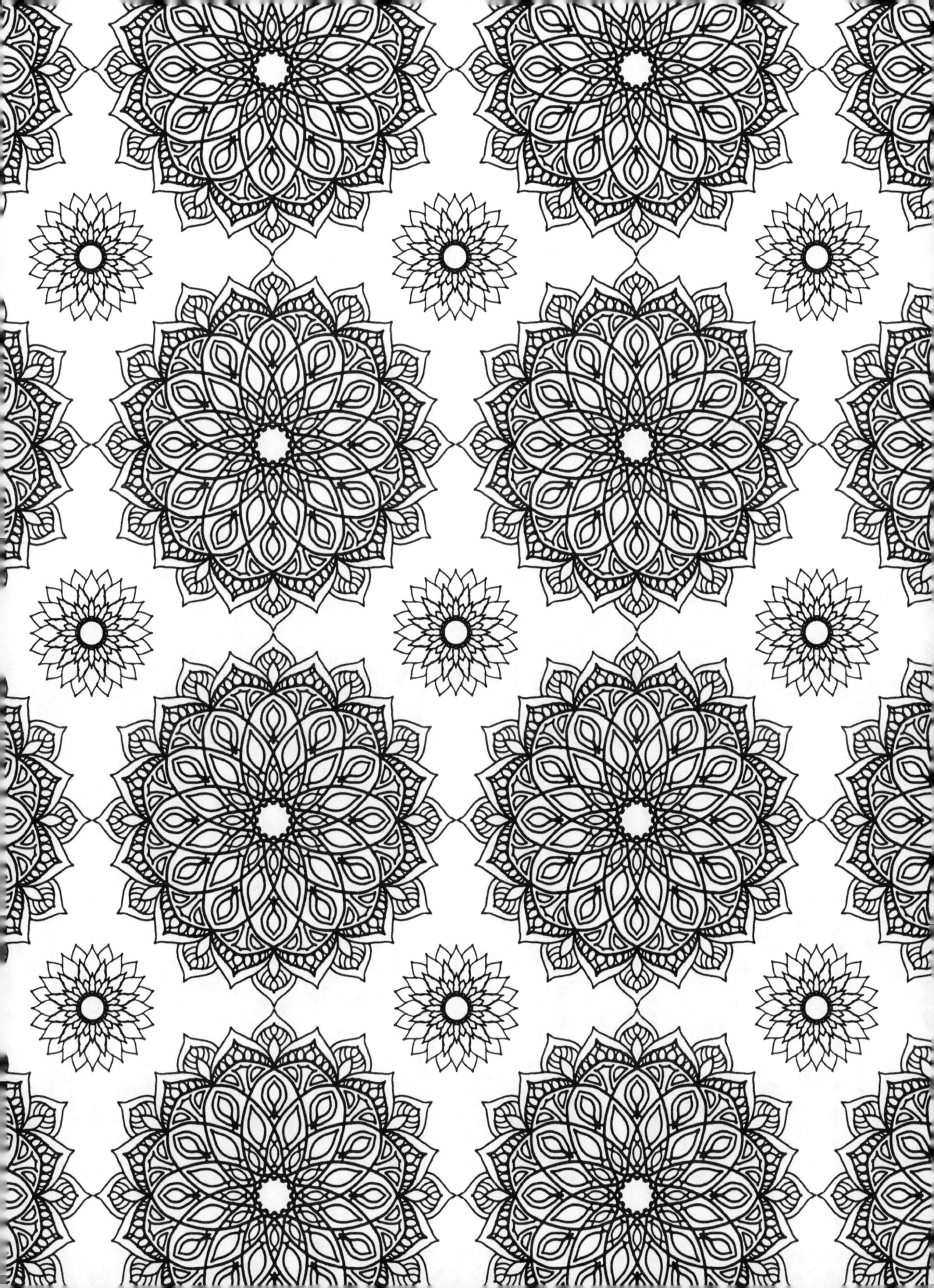

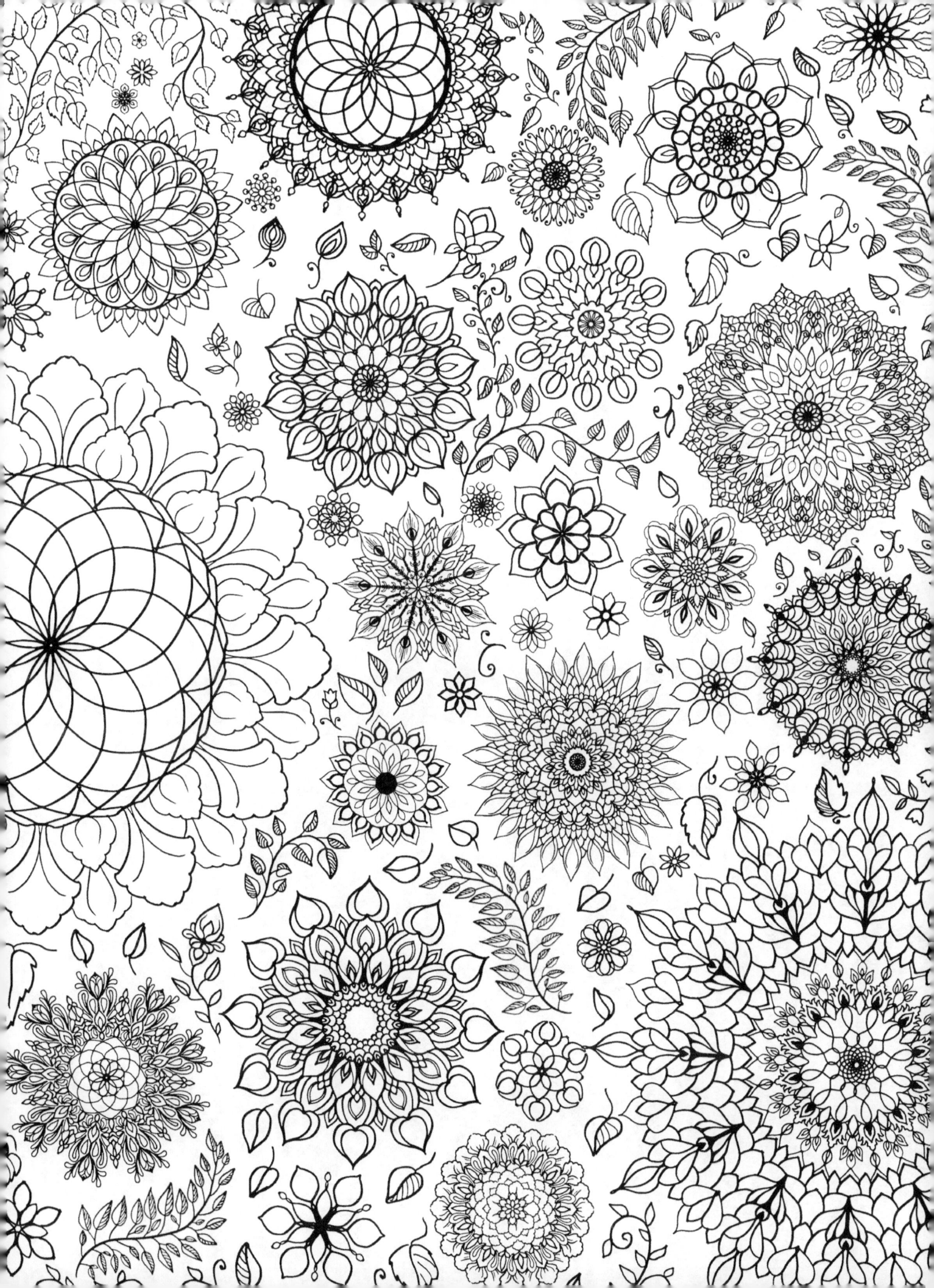

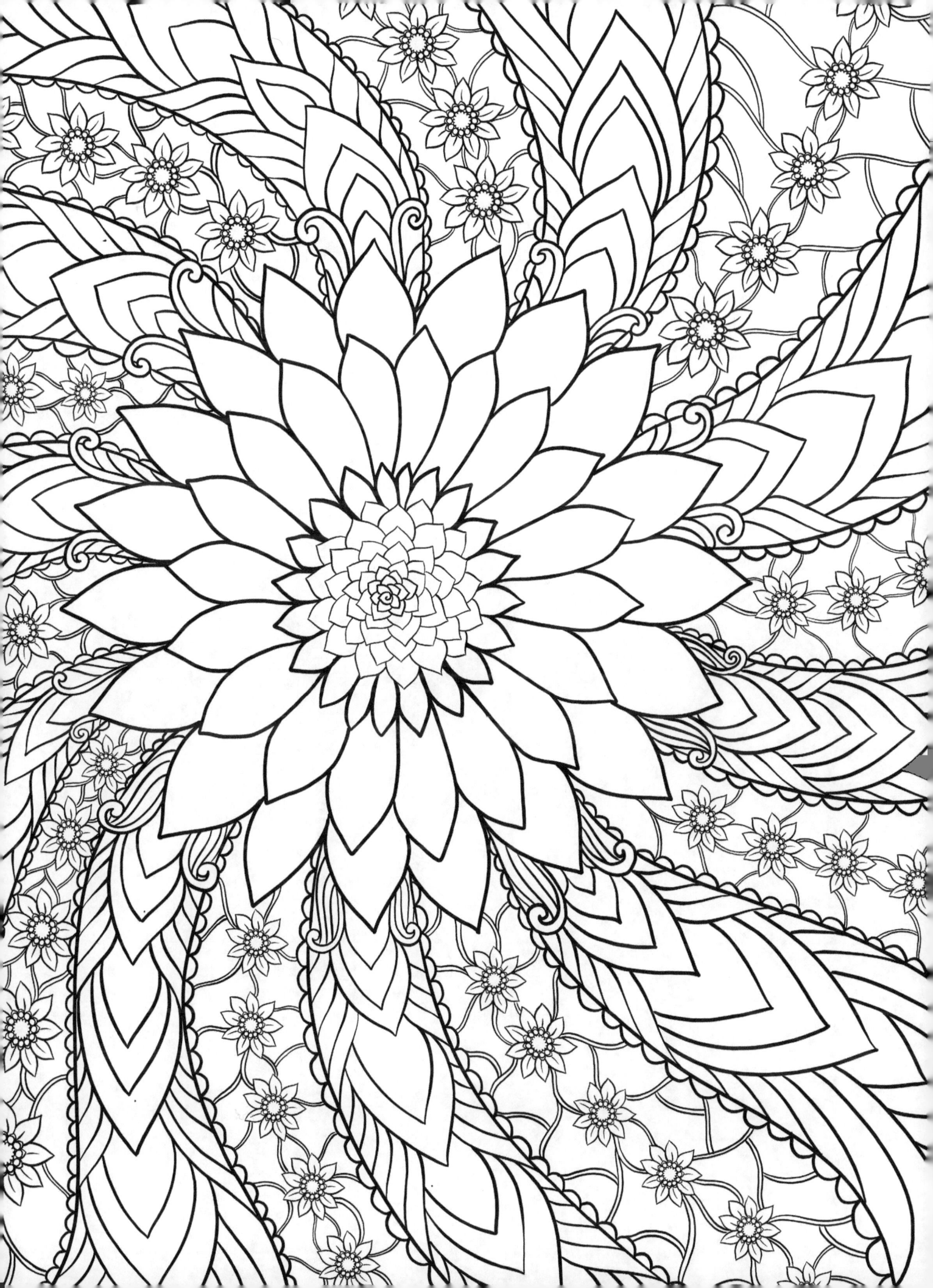

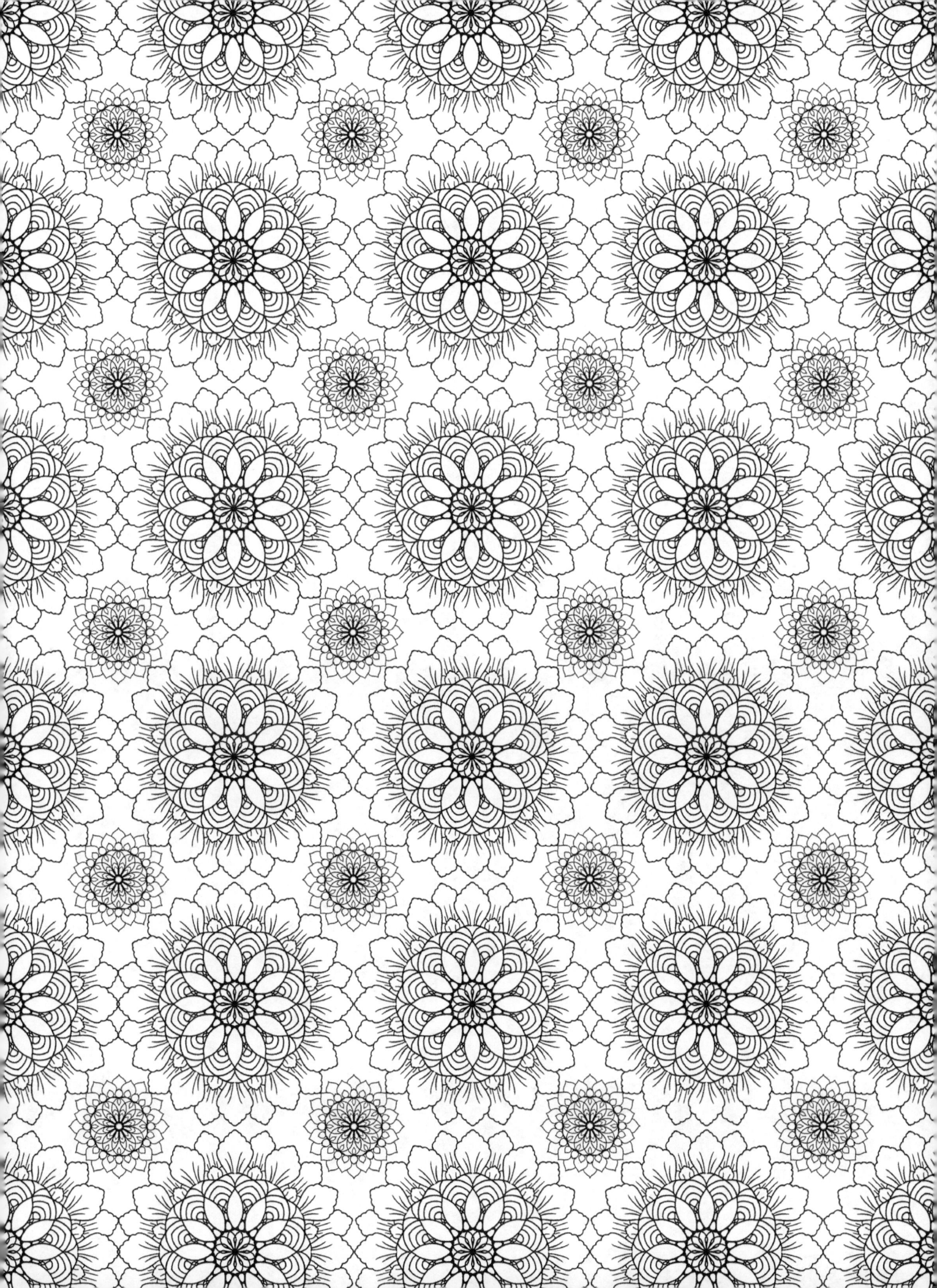

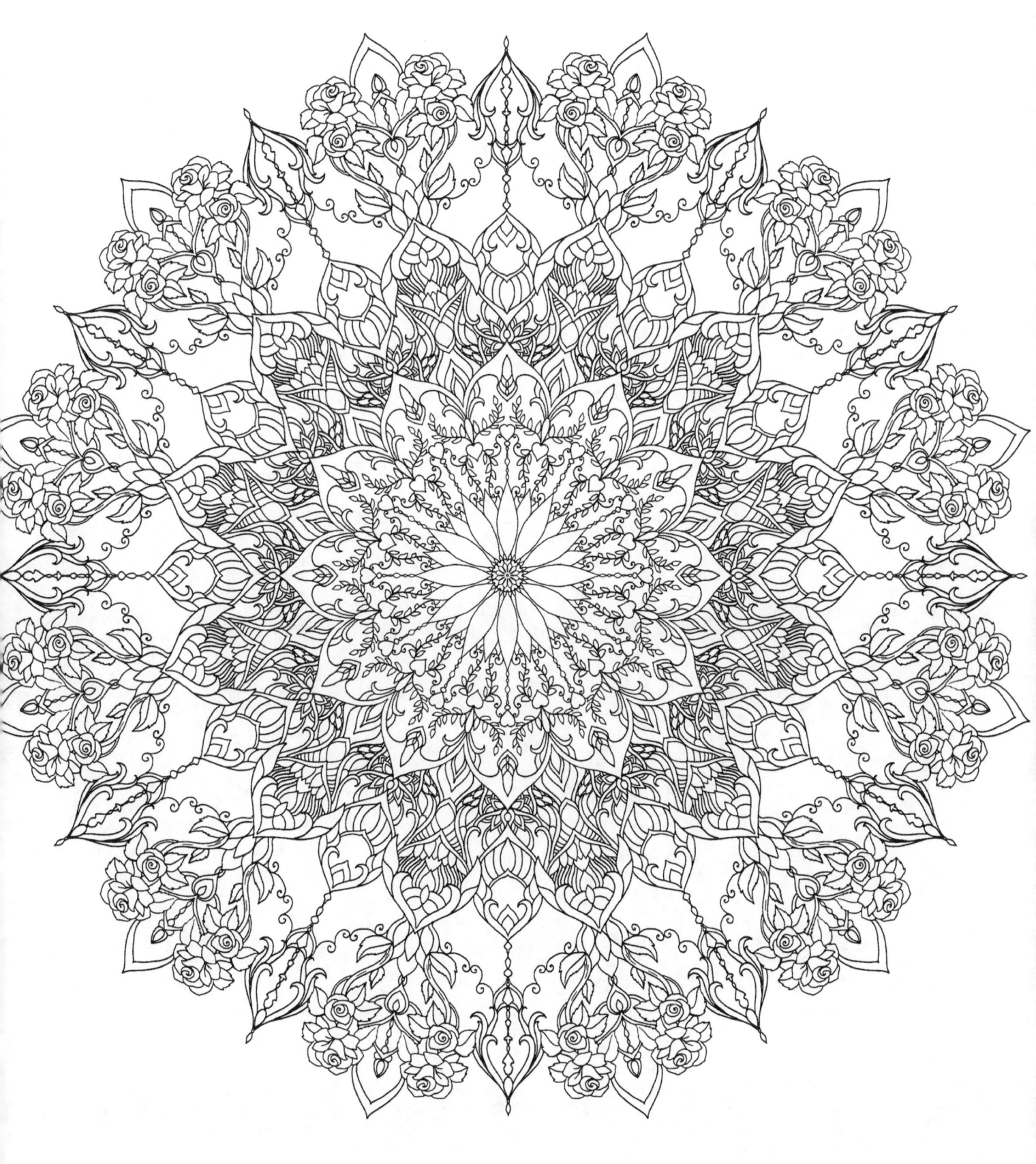

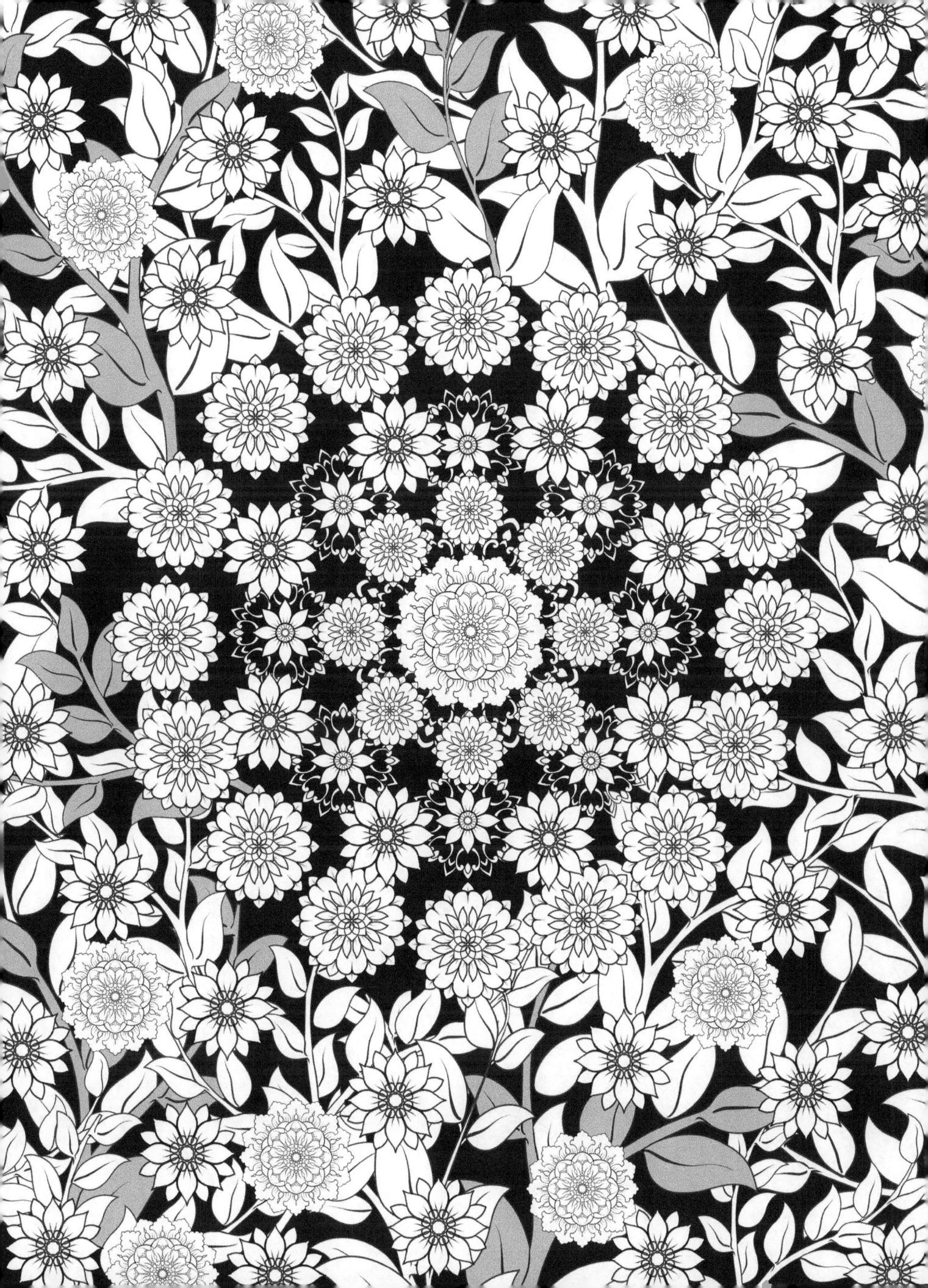

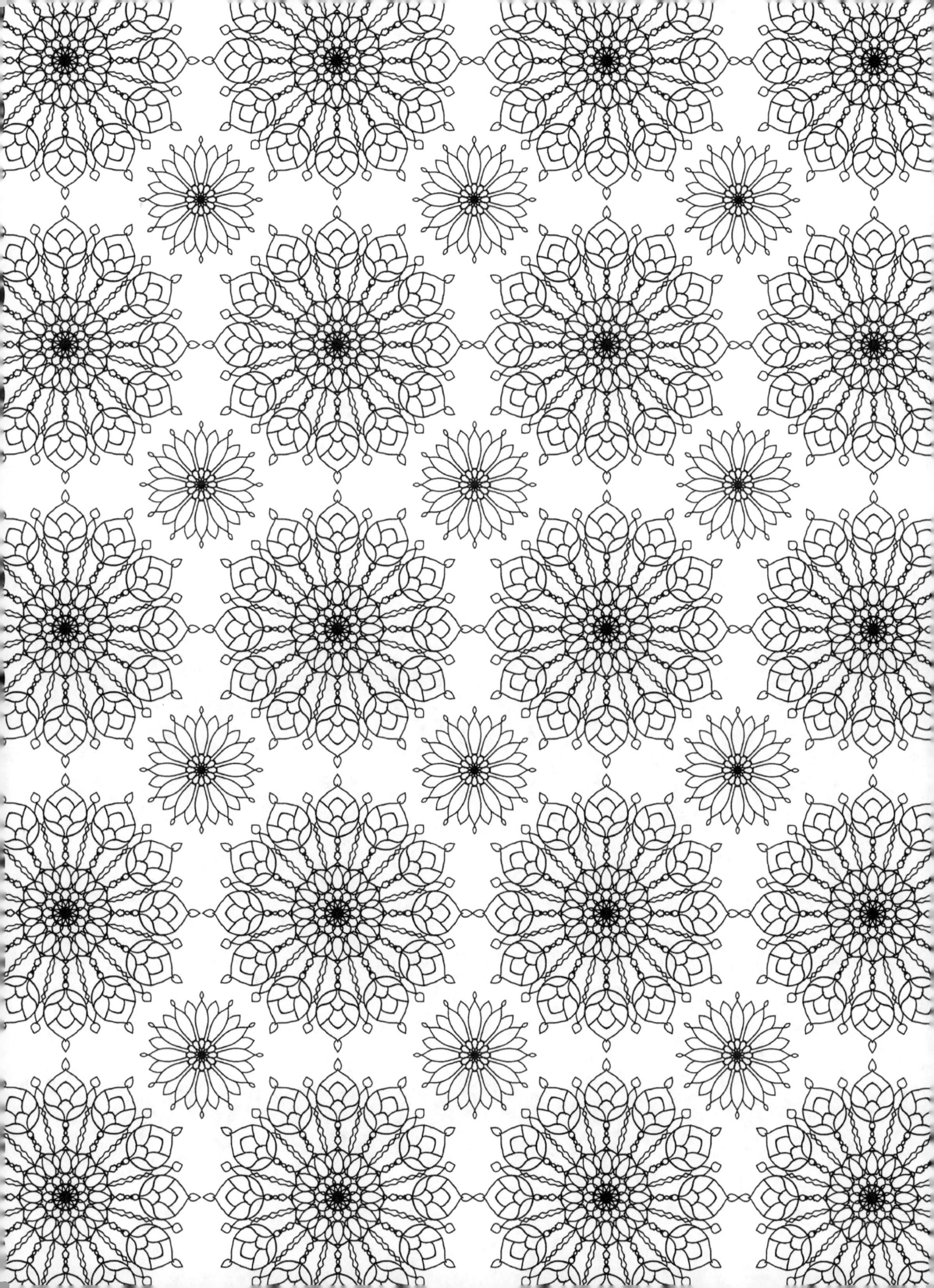

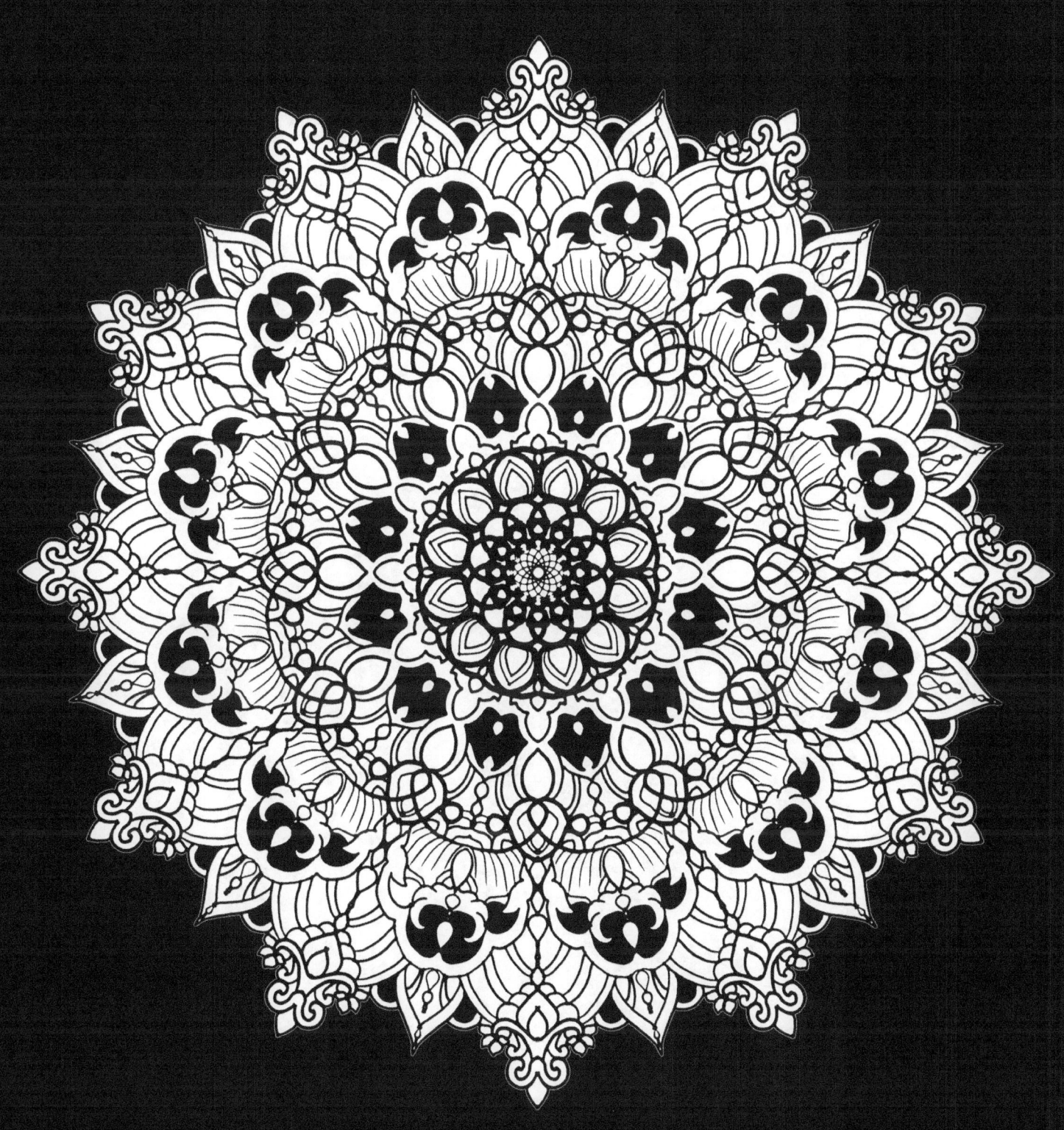

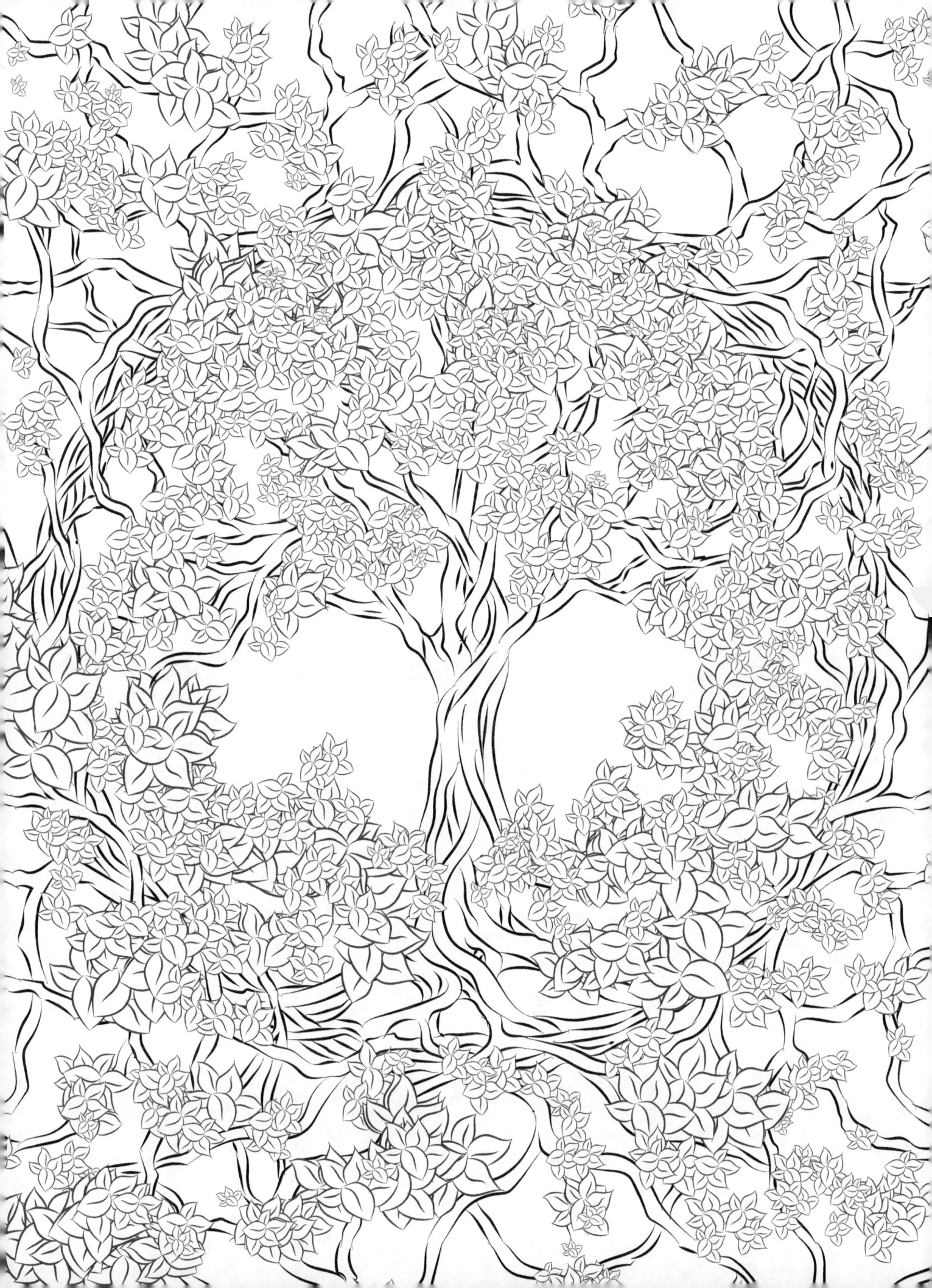

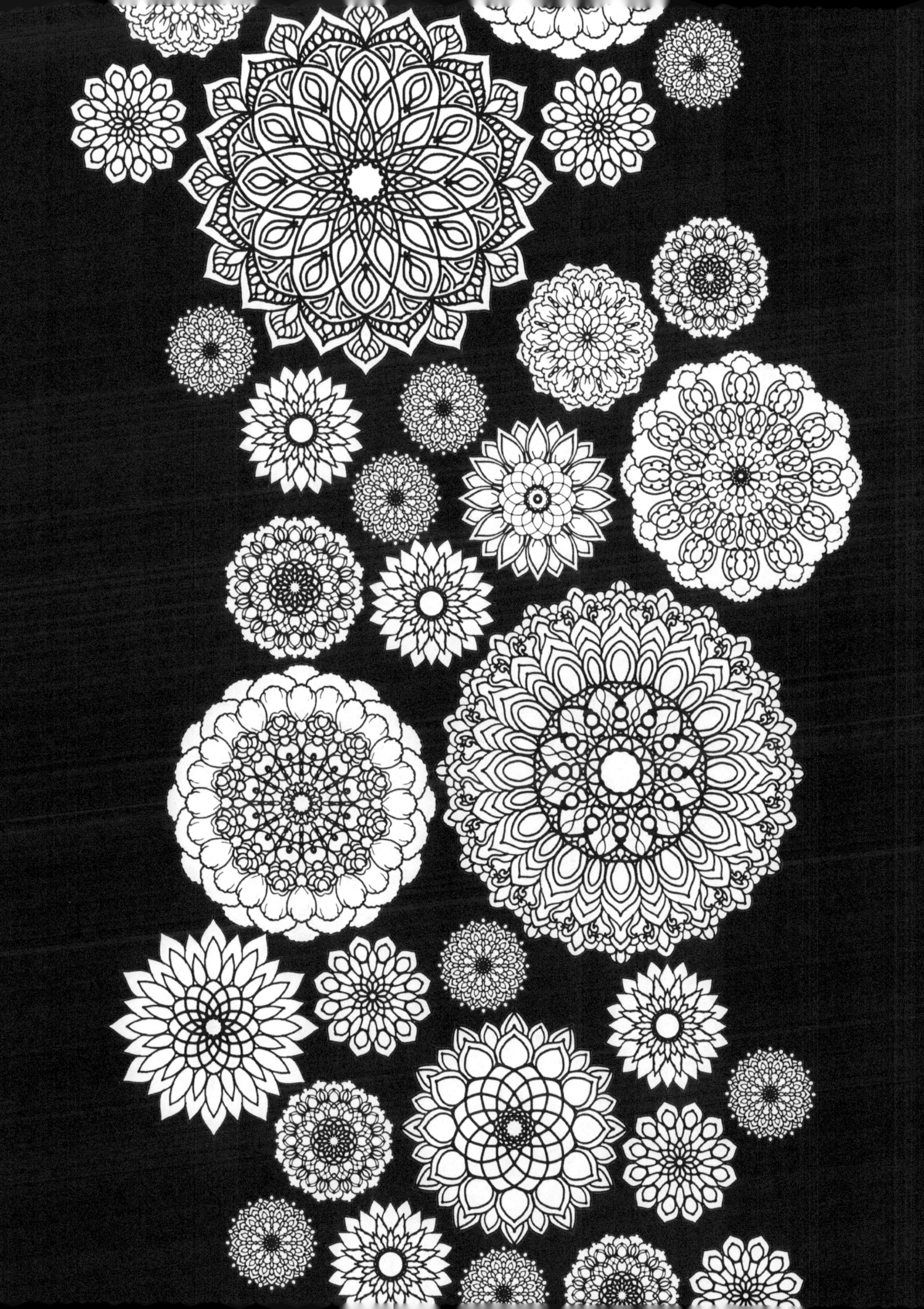

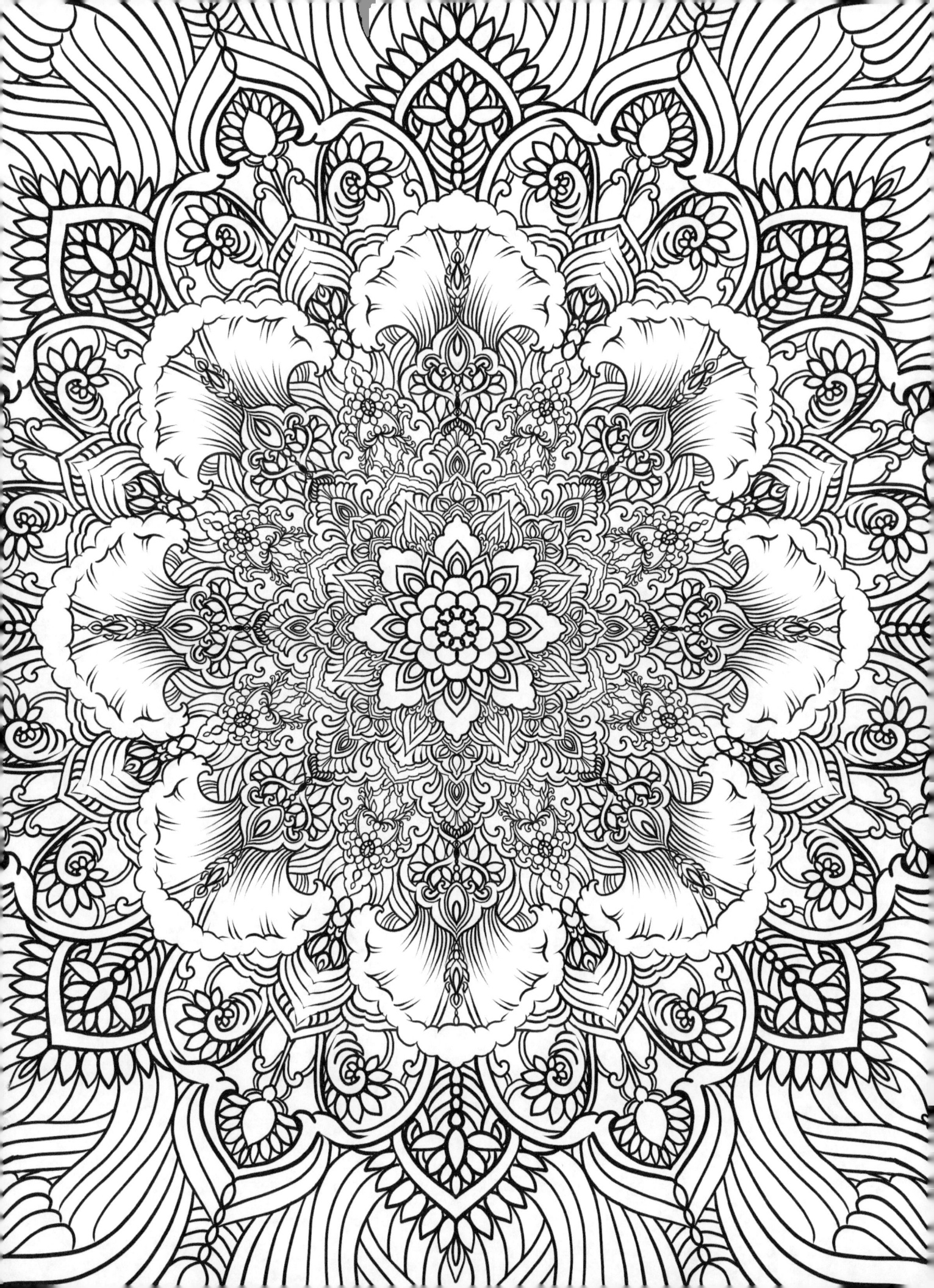

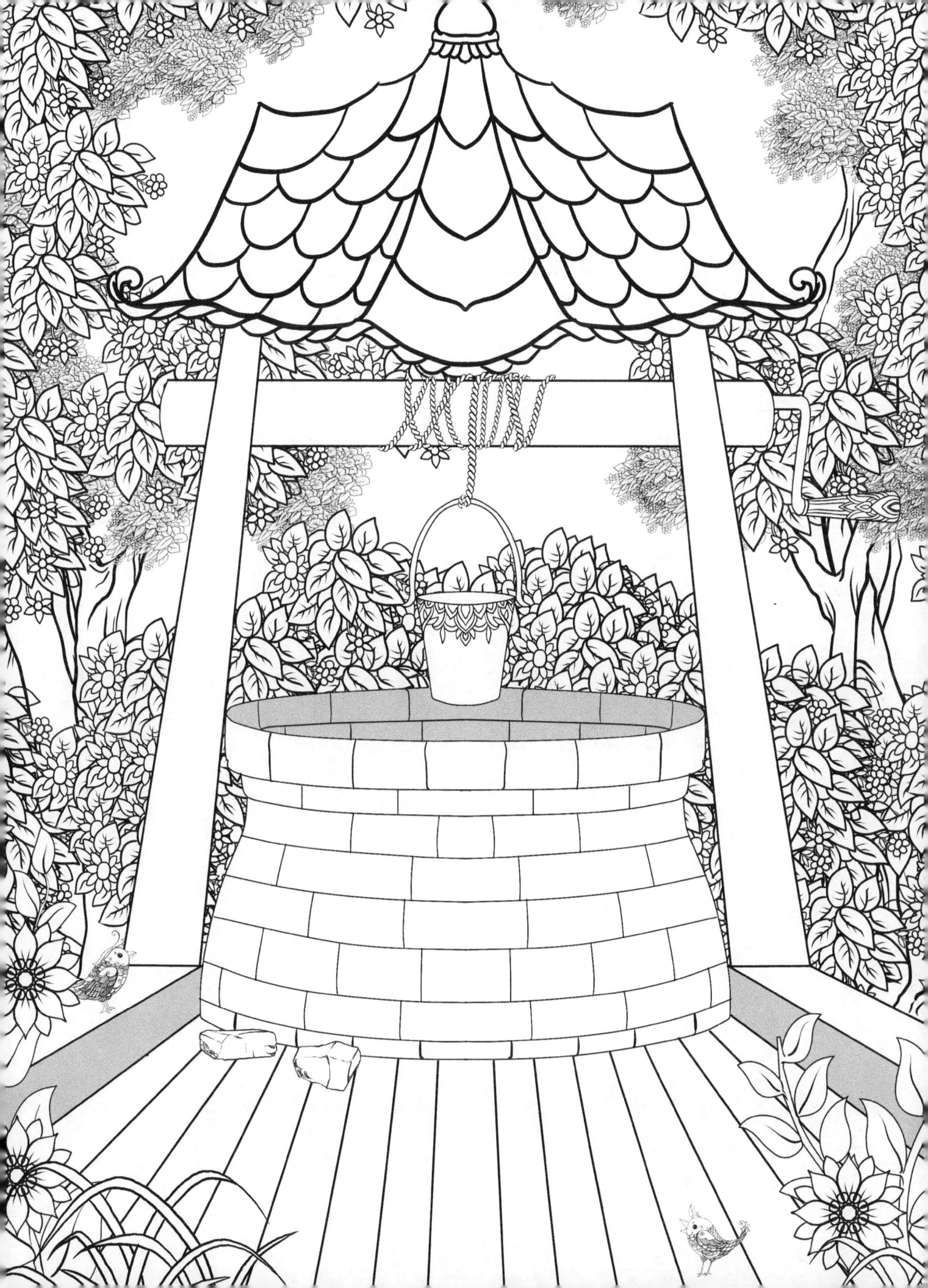

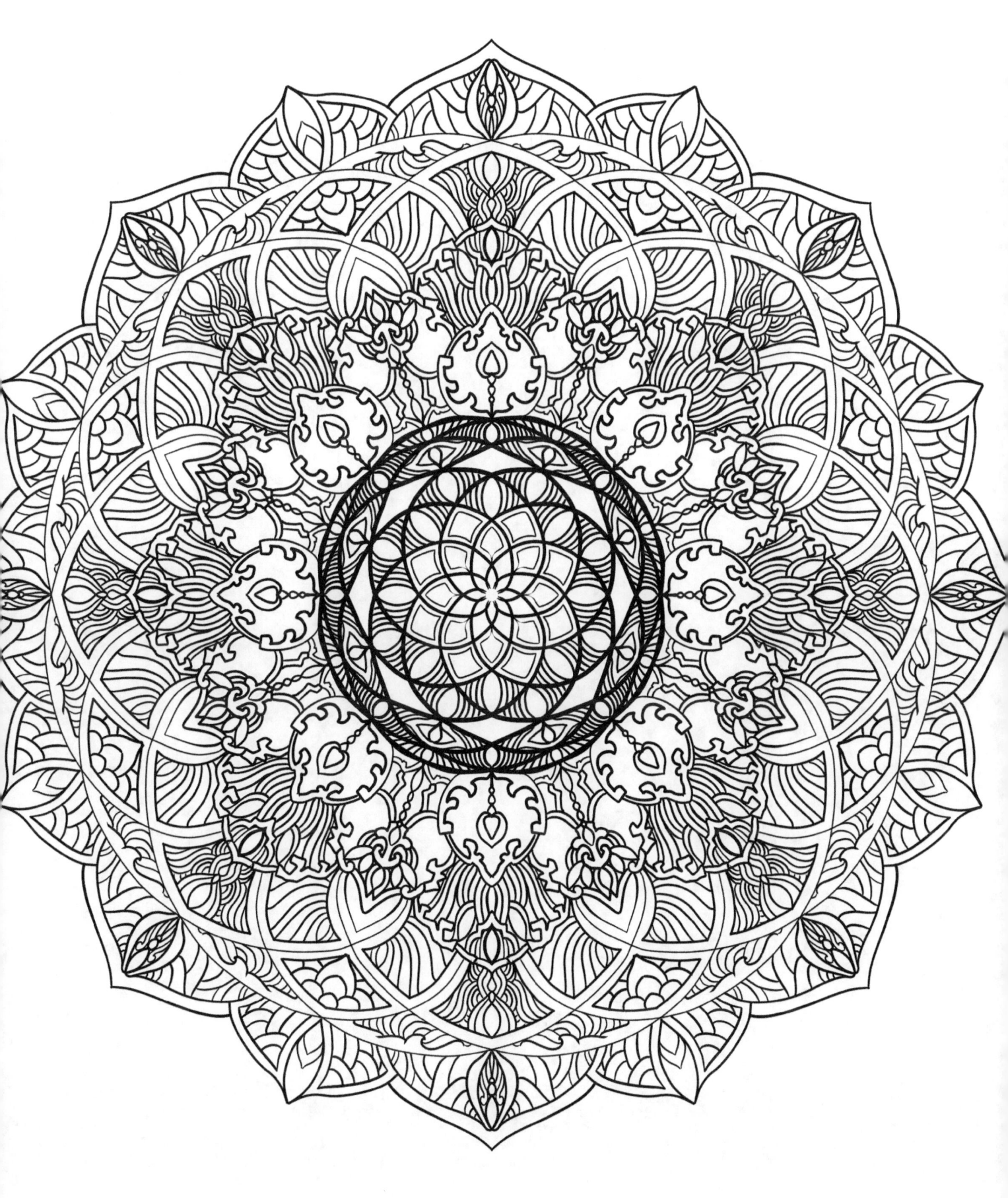

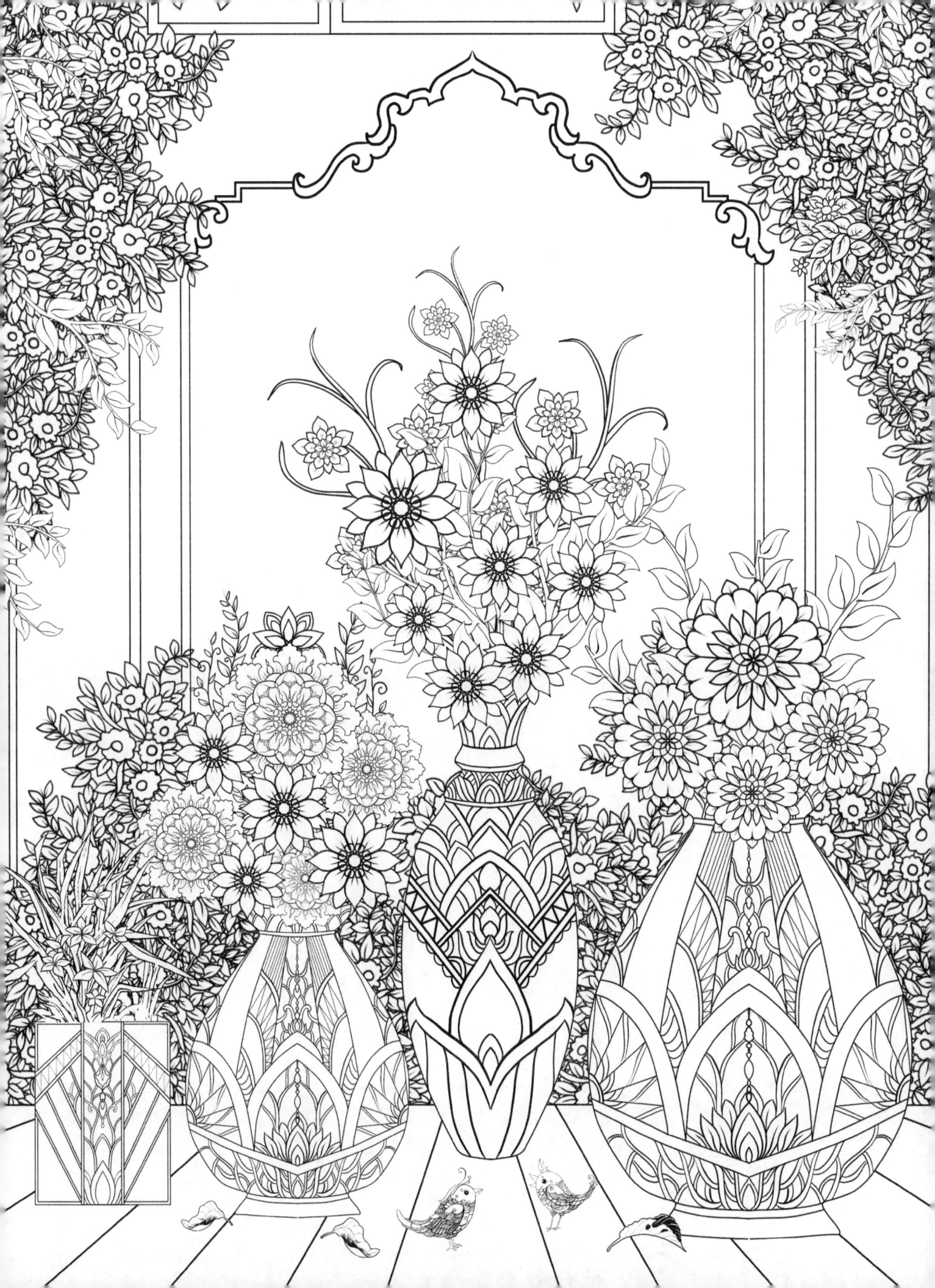

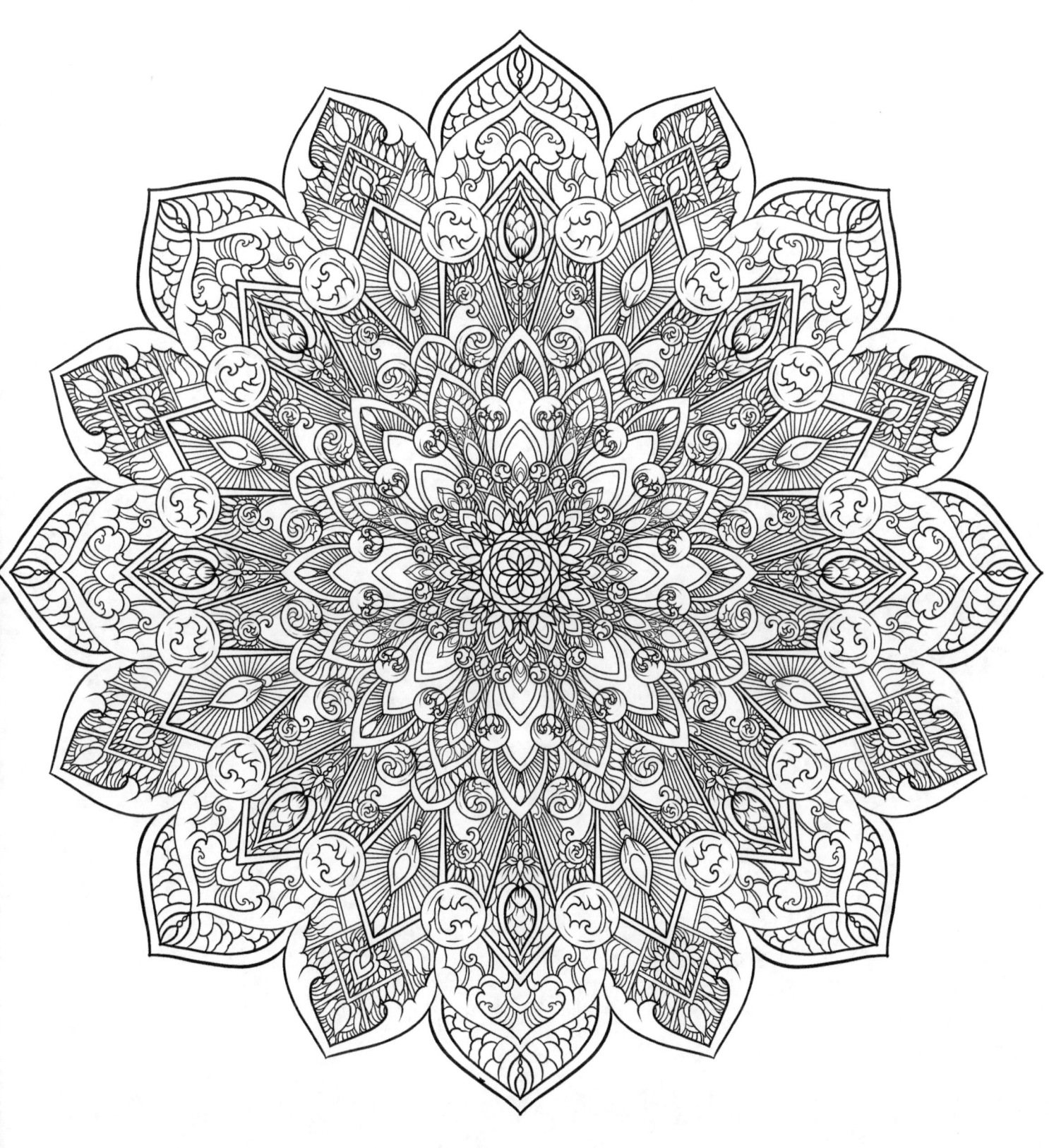

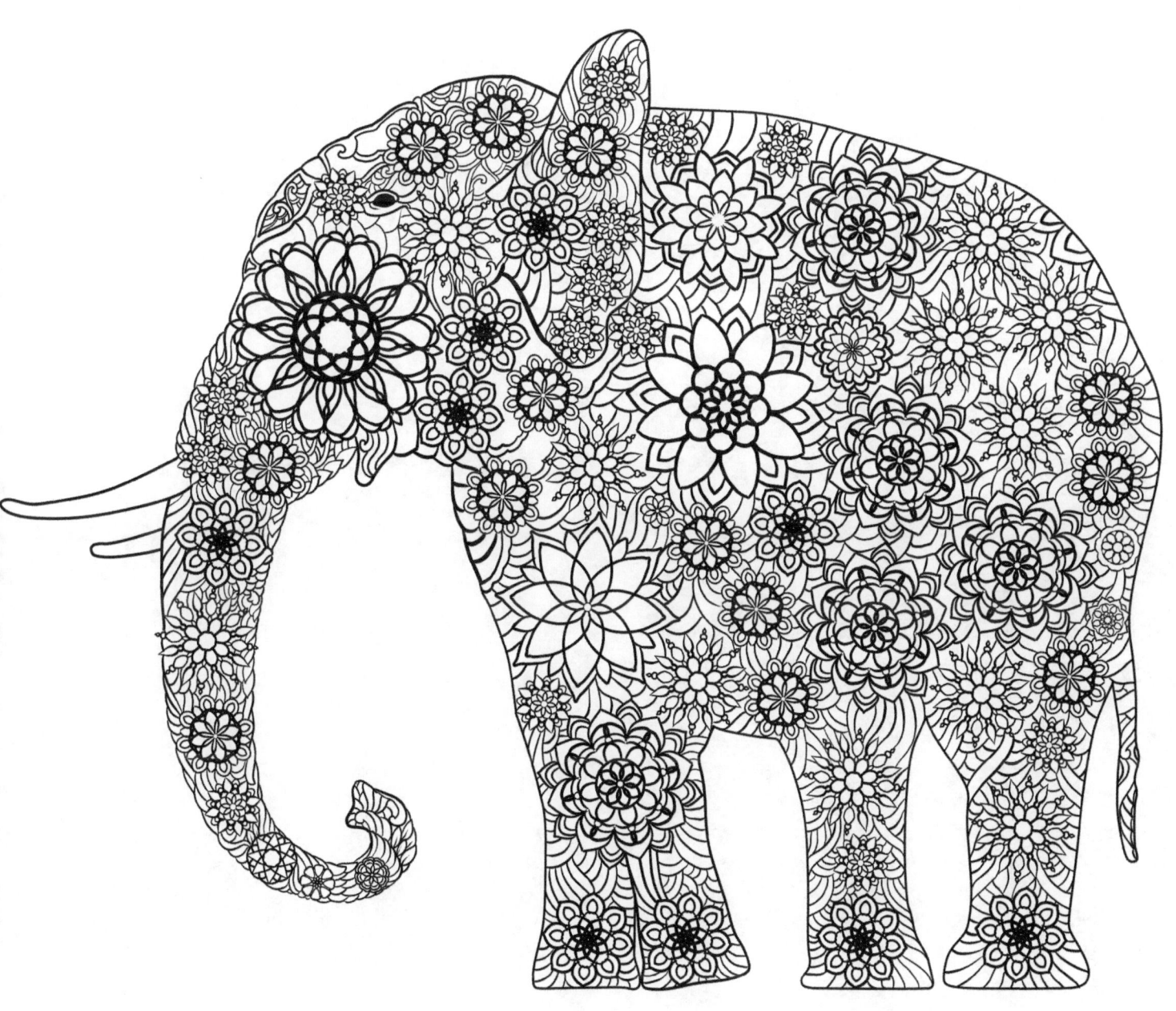

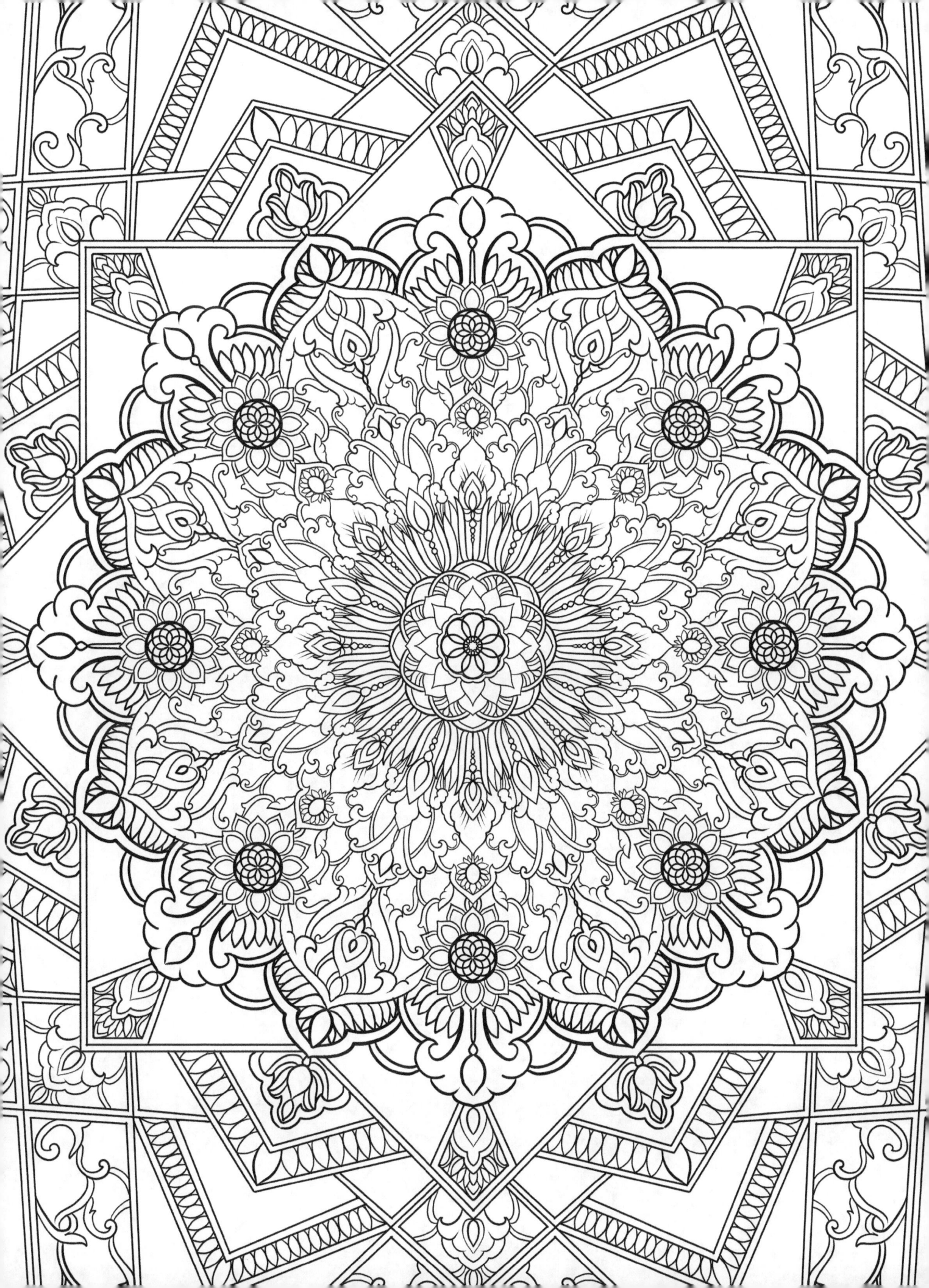

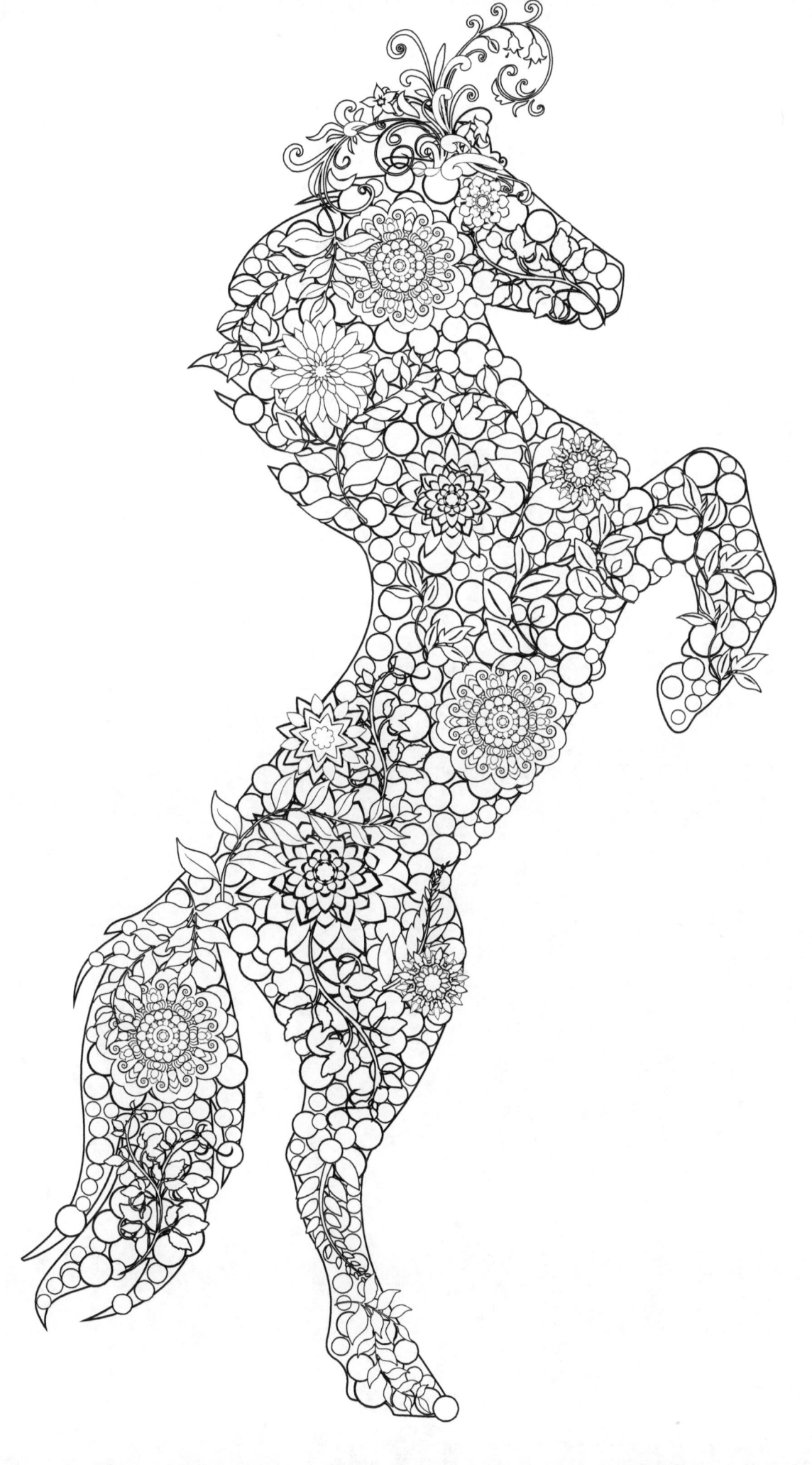

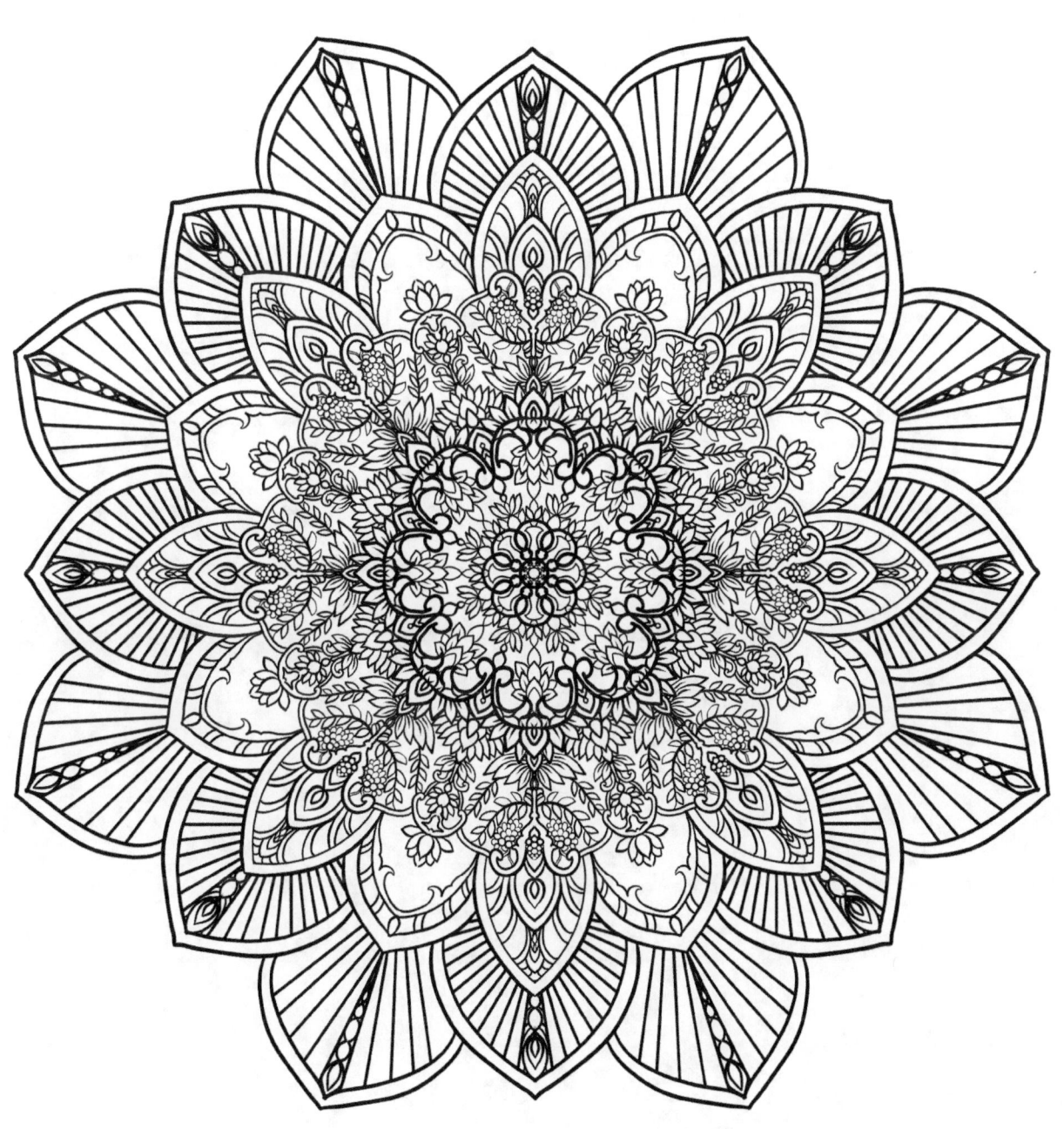

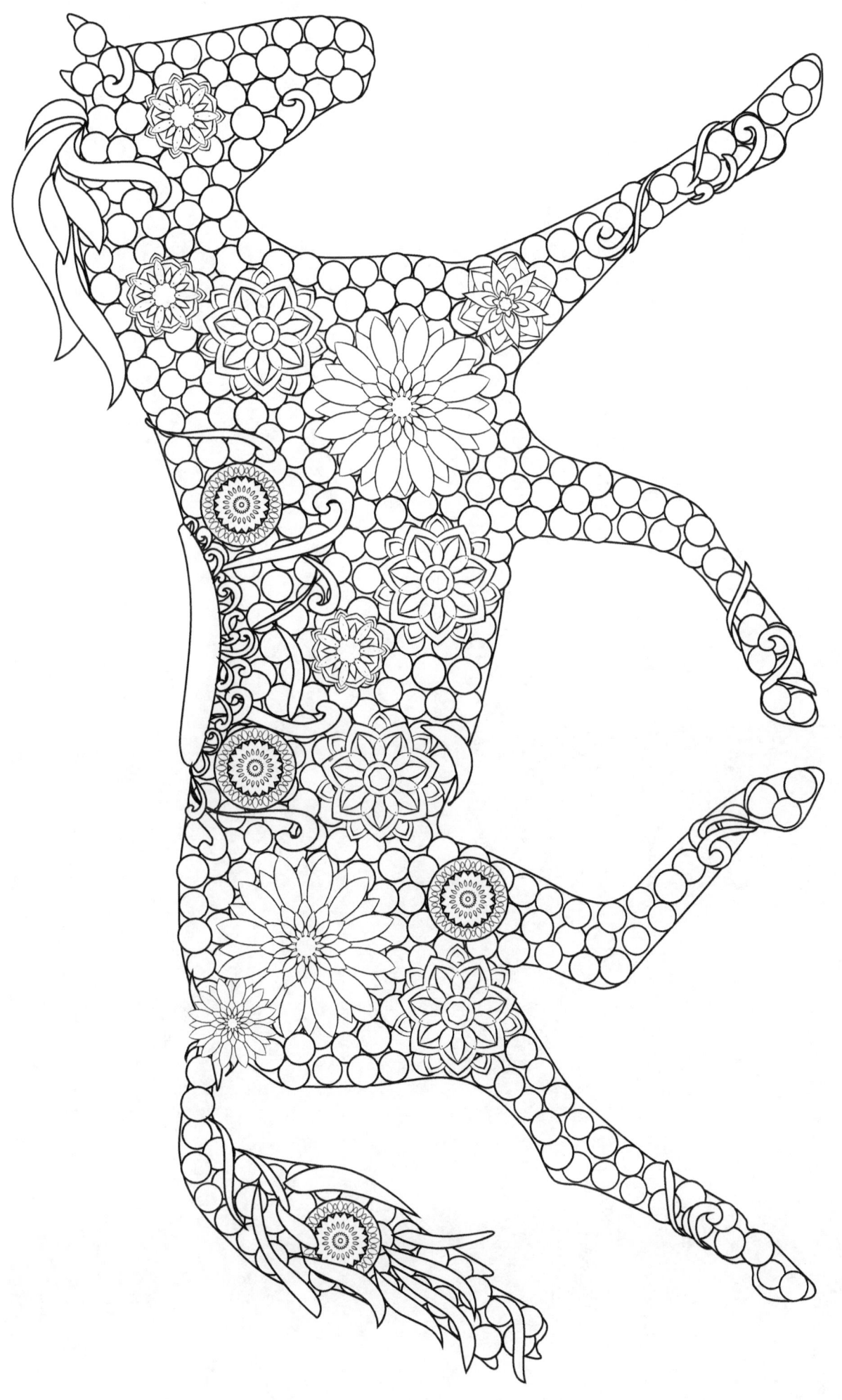

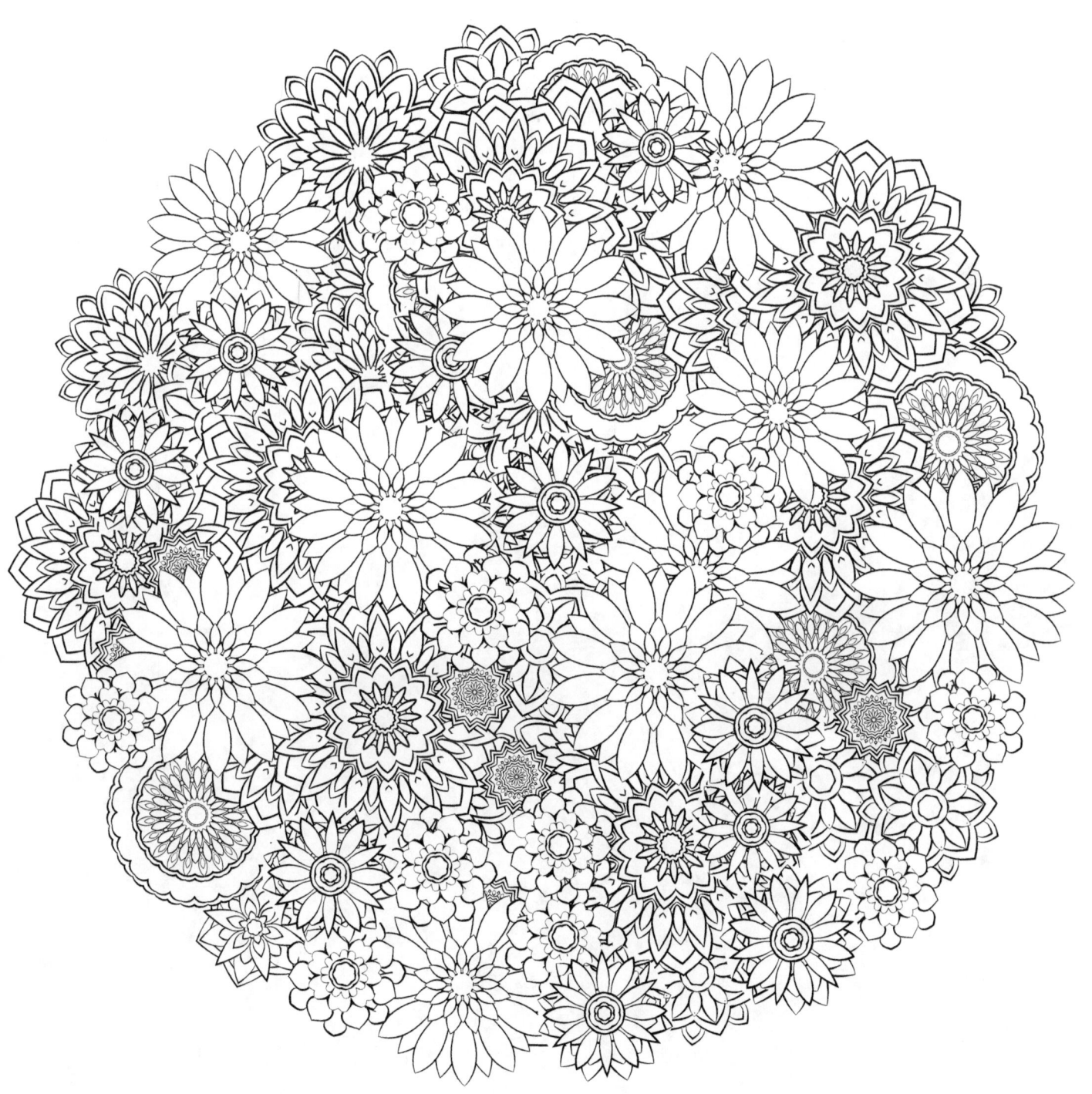

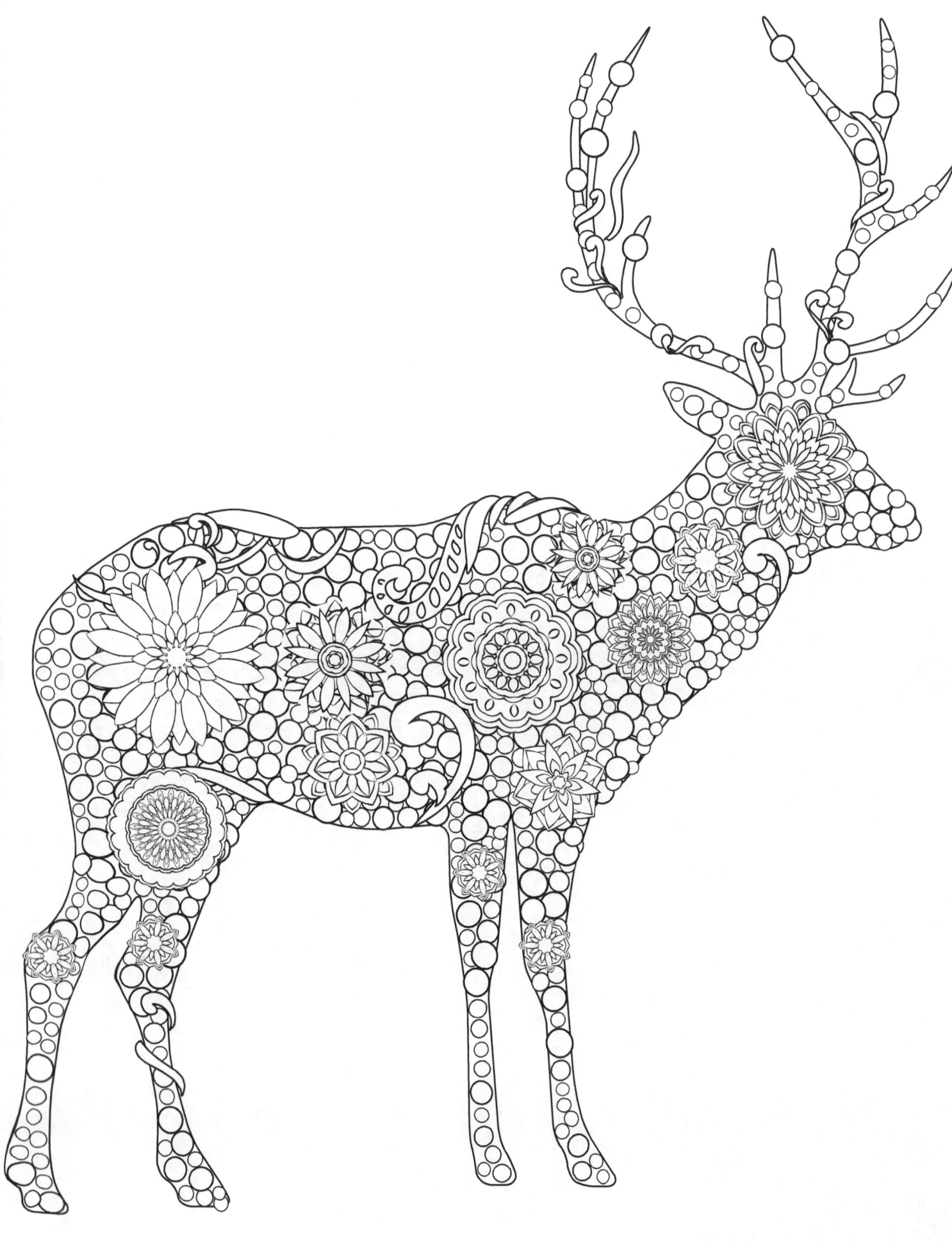